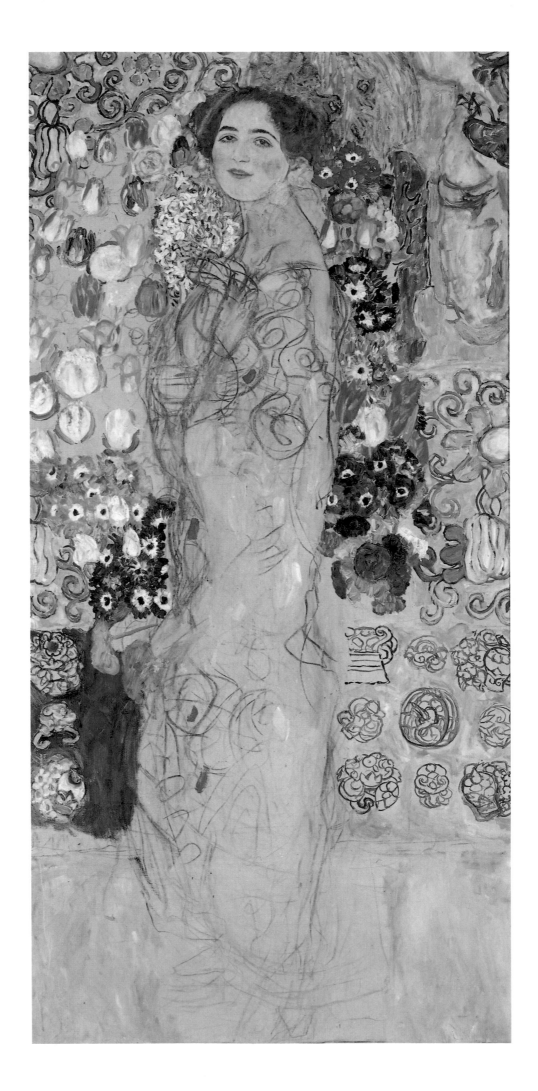

Gilles Néret

GUSTAV KLIMT

1862–1918

Benedikt Taschen

FRONT COVER:
Portrait of Adele Bloch-Bauer I (detail), 1907
Bildnis Adele Bloch-Bauer I
Oil, gold on canvas, 138 x 138 cm
Österreichische Galerie, Vienna

ILLUSTRATION PAGE 1:
Semi-nude (detail), 1914/15
Studie eines Halbaktes
Pencil, 56.6 x 37 cm
Graphische Sammlung der ETH, Zurich

ILLUSTRATION PAGE 2:
Portrait of a Lady, 1917/18
Damenbildnis
Oil on canvas, 180 x 90 cm
Neue Galerie der Stadt Linz,
Wolfgang-Gurlitt-Museum, Linz

BACK COVER:
Gustav Klimt
Graphische Sammlung Albertina, Vienna

© 1993 Benedikt Taschen Verlag GmbH
Hohenzollernring 53, D-50672 Köln
Designed by Peter Feierabend, Berlin
Translation: Charity Scott Stokes, London
Cover: Angelika Muthesius, Cologne

Printed in Germany
ISBN 3-8228-9647-0
GB

Contents

Vienna between Reality and Illusion

Gustav Klimt's home city was the fascinating turn-of-the-century Vienna of the *belle époque*. With its two million inhabitants, the city was the fourth largest in Europe, and it witnessed a cultural flowering unparalleled elsewhere. Artists and intellectuals developed enormous creativity, torn as they were between reality and illusion, between the traditional and the modern. With inhabitants such as Sigmund Freud, Otto Wagner, Gustav Mahler and Arnold Schönberg, the city was a "laboratory of the apocalypse", a late bloom, a last creative tumult before its decline.

The dominant haute bourgeoisie, known for its pretentiousness, its splendid banquets, its inordinate love of pleasure, had a catalytic effect on the city's culture.

It was out of this "laboratory" that Klimt's art grew, and his visions were at once filled to the brim with life and only too conscious of death; the traditional and the modern were dovetailed with one another, linking a passing world with an emerging one. It is fascinating to look at the sensuality of his drawing, the kaleidoscopic composition of his works, the wealth of ornamentation, and to attempt to unlock the secrets of his pictures. Above all, the viewer is held captive by Klimt's central theme, the beauty of women.

"All art is erotic", declared Adolf Loos in "Ornament and Crime". Long before Expressionism and Surrealism were credited with displaying sexuality openly in art, Klimt made it his creed, and it became the leitmotif of his work. The languid and yet exalted atmosphere of Vienna clearly incited the artist to put eroticism centre-stage, with woman in the lead.

Klimt boldly painted Eve, the prototype of woman, in every conceivable positions. It is not the apple that is seductive, but her body; she is displayed as she really is in her entirety, with no detail concealed – *Nuda Veritas* (see p. 19). Klimt contributes to the creation of a type, the recurrent castrating *femme fatale*, familiar also from the work of Aubrey Beardsley and Fernand Khnopff among others. She is on display in Klimt's official portraits of Viennese women as well as in his portrayals of *Judith* or *Salome* (see p. 29), in *Danae* (see p. 64) as in unnamed girls (*The Virgin*, see p. 71) and allegorical personifications.

Eroticism was in the air at this time: Freud saw no upright object without interpreting it as erectile, no orifice without potential penetration. Even Adolf Loos, with his right-angled art and his hostility towards ornamentation, associated horizontal lines with woman and vertical lines with man.

Fable, 1883
Even in his earliest paintings, Klimt was already giving pride of place to Woman; he never ceased thereafter to sing her praises. Here the compliant animals are positioned as ornaments at the feet of the wonderful, sensuous heroine, who accepts their obeisance as her due.

The Theatre in Taormina, 1886–88
Klimt was fascinated by Hans Makart (1840–1884), the master of the Vienna historicists; after Makart's death, Klimt continued the master's work on the stairway of the Kunsthistorisches Museum. The youthful Klimt was inspired less by Makart's rococo style than by his baroque love of lavish design.

Ancient Greece II (Girl from Tanagra), 1890/91
By presenting ancient Greece in the charming
contemporary form of a heavy-lidded Viennese
cocotte, Klimt shows that he is beginning to dis-
tance himself from Academicism, and to chal-
lenge the hypocritically respectable pretensions
of his age. In fact, he is trying his hand for the
first time at a portrait of a "femme fatale"...

Klimt's world is full of pollen and pistil, germ-cell and ovum, in views
of nature but also incorporated into bodies and garments. At times his
works were received with enthusiasm, he was celebrated and became the
favourite portrait painter of Viennese society ladies. Yet it also happened
that the undisguised eroticism of his works aroused bitter antagonism in
this decadent city going through a time of hypocritical Victorian repres-
sion. There were periodic scandals, as in the case of his paintings for the
University, which finally had to be removed. Although Emperor Franz
Josef awarded Klimt the Golden Order of Merit, he declined three times
to approve his appointment as professor at the Academy.

Klimt rebelled: "Enough of censorship... I want to get away... I refuse
every form of support from the state, I'll do without all of it."[1] Wishing to
be independent of large-scale state commissions, he concentrated accord-
ingly on society portraits and landscape paintings. He knew just how to
give these portraits an air of respectability, while actually painting what
interested him to the exclusion of almost everything else – the bewitching
eroticism of women, ever-present Eros. Those who commissioned the
portraits were well pleased. To keep up appearances, Klimt could not
paint the women nude, so he clothed them in fanciful gowns concealing
their nakedness yet drawing attention to it all the more. Floral motifs and
ornamentation satisfied the need for fig leaves felt by a society enthusing
over Art Nouveau. Klimt's structuring of pictures in the manner of the
Byzantine mosaics of Ravenna commanded respect, and attention was de-
flected from the actual content by the abundance of detail: flowing hair,
stylised flowers, geometrical décor, extravagant hats, enormous fur
muffs. Yet these same attributes intensify the erotic radiance of the
woman in the centre of the picture. Before clothing the women in his pic-
tures, Klimt clearly painted them naked. A canvas left unfinished at his
death – *The Bride* (see p. 91) – reveals this secret. The Orient, with its
bestiary of birds and animals, plants and exotic people, contributes to the
décor. The last works, often pyramid-shaped compositions, are flooded
with curves and spirals, mystical whirlpools and bright assorted shapes. A
newly created world appears around the central figures, enticing the
viewer towards the depths of the unconscious and the labyrinths of the
mind.

If today the Viennese painter Hundertwasser is in need of a theme, he
immerses himself – on his own admission – in the detail of a Klimt dress.
He enlarges the detail to the size of his canvas, and with the help of what
he calls "transautomatic" repetition he creates a dark world of obsession.
In so doing he continues in Klimt's tradition, showing the way, as Klimt
did, to an unknown world.

More colour reproductions are sold in museums of the works of Klimt
than of any other artist. Not only is his fantasy world seen as the expres-
sion of a society; decadency's importance is also attached to his graphic
style, which helped to blaze the trail for Modernism.

Klimt's origins had considerable importance for the development of his
art. He was born on 14th July 1862 in Baumgarten near Vienna, the sec-
ond of the seven children of a hard-working yet poor engraver. His
younger brother, Ernst, also became an engraver, and the two brothers
often worked together until Ernst's death in 1892.

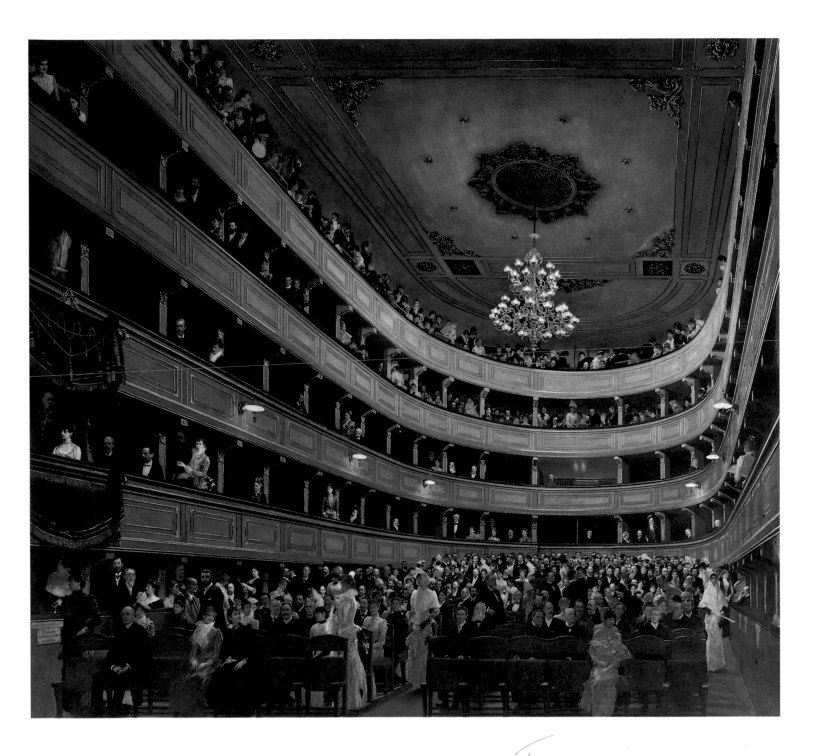

When he was scarcely fourteen years old, Gustav Klimt became a student at the School of Applied Art in Vienna. For seven years he, his brother Ernst, and Franz Matsch studied a range of techniques, from mosaics to painting and fresco work, under Professor Ferdinand Laufberger. The three worked so well together that Laufberger was able to procure design commissions for them.

In 1880 they undertook their first official commissions, the four allegories for the Palais Sturany in Vienna and the ceiling paintings in the Karlsbad spa. Klimt's style at this time developed a certain baroque virtuosity, based above all on the adaptation of classical antiquity as practised by Hans Makart, the luminary among painters in Vienna at that time. Under his auspices Laufberger's three pupils transposed several woodcuts created by Dürer in celebration of the triumphal procession of Maximilian I into large-scale decorations in honour of Emperor Franz

Auditorium in the Old Burgtheater, Vienna, 1888
The theatre, as meeting-point of reality and illusion, offered Klimt the opportunity of casting the audience as players: what is reality, what mere illusion?

9

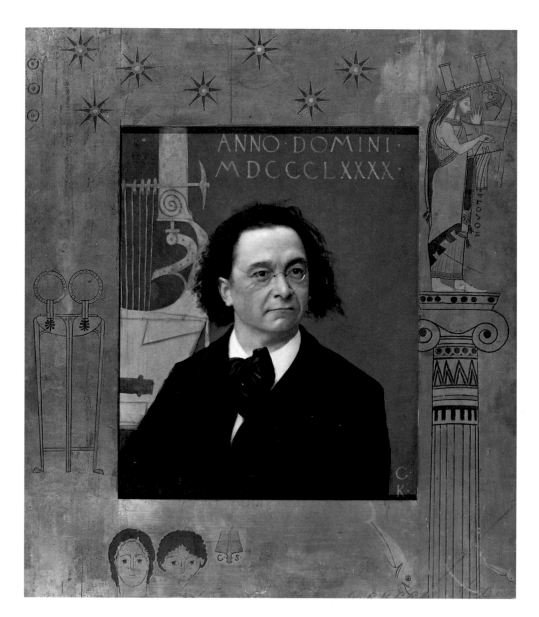

Portrait of Joseph Pembauer, the Pianist and Piano Teacher, 1890
This portrait is an instance of Klimt's photographic manner of painting faces during this period – a hyperrealist before his time.

Josef's silver wedding. Klimt's first contact with the world of Dürer provided him with rich iconographic resources which he was to draw on and develop further at a later date. In the first pictures, such as *Fable* (see p. 7), he was still working within a convention. The animals lie at the feet of the delightful, sensuous heroine, serving only to show this first voluptuous Eve to her best advantage.

In 1886 the construction of the Burgtheater was completed. The three young men were commissioned to paint scenes from the history of the theatre on the tympanum and the stairway ceilings. Klimt's work developed along different lines from that of his two friends. He was no longer satisfied with classical motifs alone, but sought to supplement them with realistic portraits, painted with photographic precision. In this way, he introduced something distinctive of his own time into the paintings, as in *The Theatre in Taormina* (see p. 6).

It should not be forgotten that Klimt was an engraver's son, thoroughly

Portrait of a Lady (Frau Heymann?), c. 1894
Coolness and reserve mark this lady, while not
yet a *femme fatale*, as one of Freud's castrating
women.

schooled in a wide range of techniques. He spent many hours studying
the antique vases in the Imperial Museum, or copying such pictures as
Titian's *Isabella d'Este*. In this way he acquired outstanding technical
skills, and his work never seemed like that of a beginner. The public were
quick to appreciate his accomplished allegories, his optical illusions, his
persistently baroque style – features which continued to mark his work.

Hans Makart (1840–1884), the prestigious master of the historicist
school of painting in Vienna, fascinated the young artist. At the time of
Makart's untimely death – he was only 44 years old – the decoration of
the stairways in the Kunsthistorisches Museum was incomplete. The three
young men were given the dubious honour of completing his work. The
trio could contemplate at length the gigantic works in progress in his aban-
doned studio. They were charged with the completion of eight spandrel
and three intercolumnar paintings, which were intended to represent the
history of art from ancient Egypt to cinquecento Florence. For Klimt this

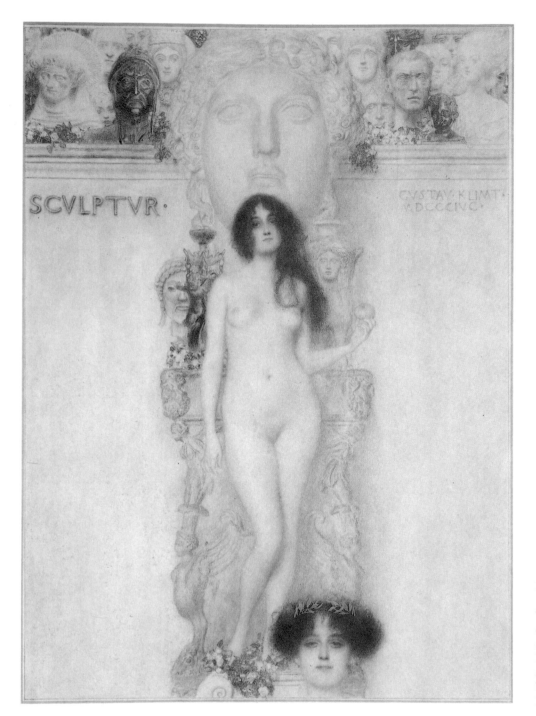

Finished drawing for the allegory *Sculpture,* 1896
The figures exemplifying the sculptor's art in every age are rigid; they see nothing. Yet the personification of "Sculpture" herself springs directly from life, and her living eyes gaze seductively at the beholder. This closeness to life was to become one of the most distinctive qualities of Klimt's art.

became a moment of intense searching: faced with the challenge of adapting classical antiquity without falling over the brink into academicism, he began at the same time to develop symbolist ornamentation together with decorative and floral themes, pre-figuring the manifesto which he was to proclaim at the "Internationale Ausstellung der Musik und des Theaters" (International Exhibition of Music and Theatre) in 1892.

The young artist was fascinated not so much by the rococo resonances in Makart's work as by his truly baroque exuberance in decoration and figural depiction. This influence was long-lasting, becoming especially apparent when Klimt tackled what Freud termed the complex of the "horror vacui", filling the entire background of his pictures with an abundance of shapes. In the gouache *Auditorium in the Old Burgtheater, Vienna* (see p. 9), the "horror vacui" can already be felt – every millimetre of the canvas is filled with some detail or figure. This subject would lead

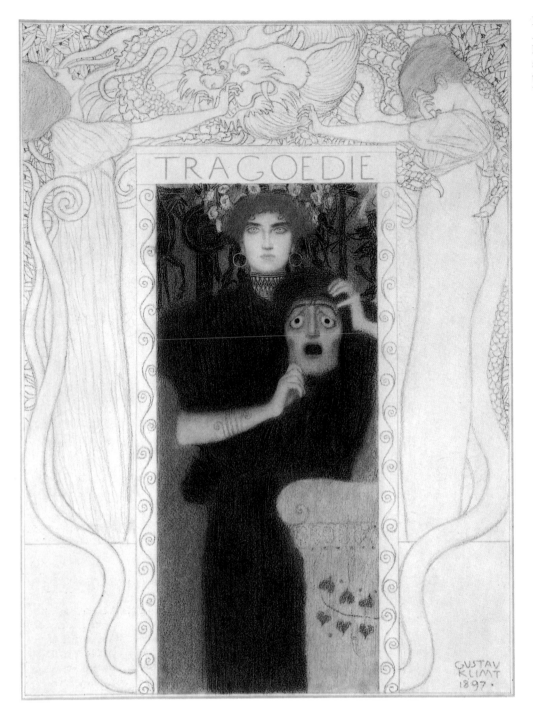

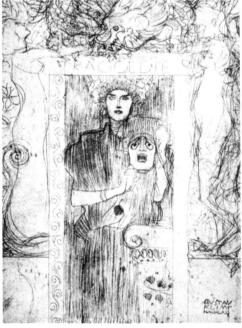

Finished drawing for the allegory *Tragedy*, 1897
Although Klimt's task was to depict the whole history of art on the walls of the Kunsthistorisches Museum, he could not resist the temptation to present his female figures as denizens of the Viennese demi-monde.

Sketch for the allegory *Tragedy*, 1897/98

one to expect a view of the stage as seen from the door into the auditorium; instead, Klimt painted the auditorium as seen from the stage, thereby turning reality inside out, making members of the audience into trompe-l'œil actors who have all the appearance of being on parade. They each look as if they had just stepped out of their own individual portraits, decked out all ready for a fancy-dress ball.

It was not long before the three friends were receiving commissions for portraits, and in this way Klimt began to establish himself. The portraits were painted from photographs, a process which met with great approval. A certain photographic precision in the portrayal of faces was to remain characteristic of Klimt. The *Portrait of Joseph Pembauer, the Pianist and Piano Teacher* (see p. 10) is typical of these photographic portraits, with features bordering on the hyperreal. Yet Klimt also wanted to introduce his recently acquired familiarity with classical Antiquity into the picture,

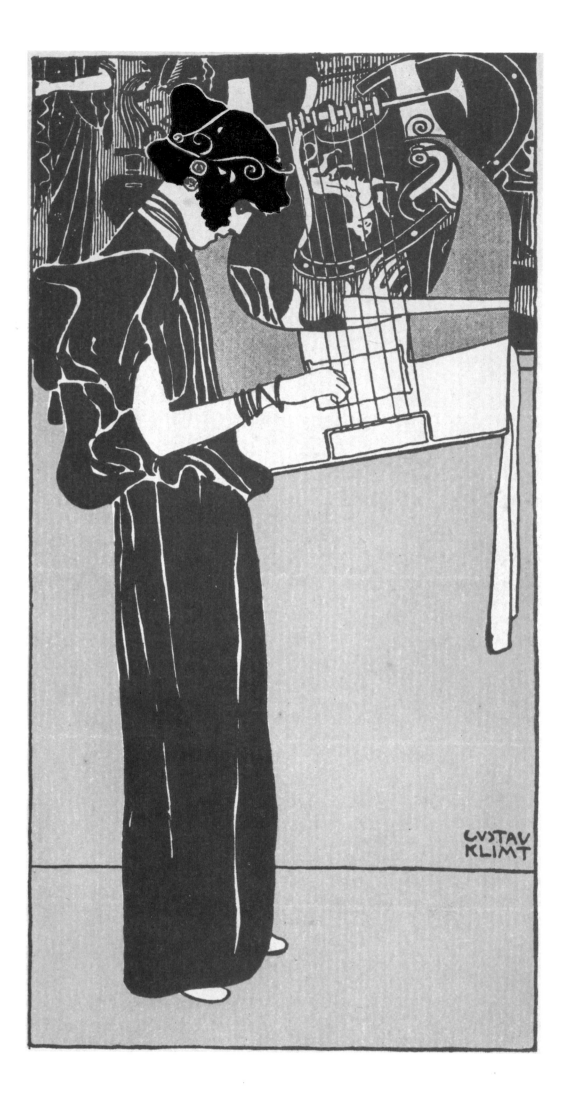

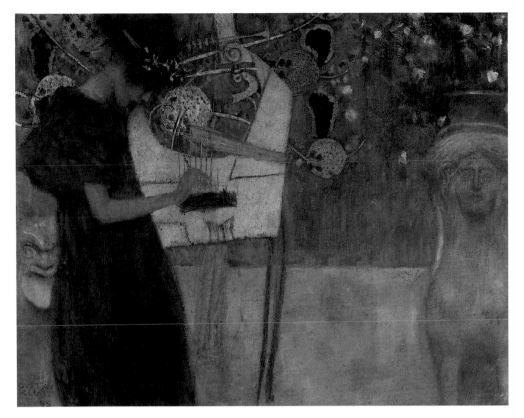

Music I, 1895

Music II, 1898

filling the wide frame with classical elements, such as the Delphic oracle, which seem to provide a commentary on the portrait. The frame becomes part of the picture, and has both decorative and symbolic significance. The excess of décor also serves to heighten by contrast the face or figure in the centre of the painting.

From the beginning Klimt dared to cross the hypocritical boundaries of respectability set by Viennese society. The eleven allegorical paintings undertaken for the Kunsthistorisches Museum were supposed to include a figure representing classical Greece, but in the *Girl from Tanagra* (see p. 8) one cannot help recognising a Viennese cocotte, heavy lidded and made up like a "girl of easy virtue" – Klimt's contemporary. In spite of the Greek amphora behind her, giving an emphatically classical setting, this is Klimt's first *femme fatale*, and respectable society took exception to her. Again, and in spite of the classical vocabulary and allusions to Antiquity, the personifications in *Sculpture* (see p. 12), *Tragedy* (see p. 13), *Music I* and *Music II* (see p. 14/15) are thoroughly Viennese, with their bouffant hair-styles and languid demi-monde air...

In Plato's "Symposium" one encounters two types of Venus, the celestial and the vulgar. Renoir makes the same distinction: "Naked woman rises either from the sea or from bed; she is called Venus or Nini, there is no better name for her..." The academic, idealised nude is applauded by society, particularly when a historical message can be discerned, but an everyday naked woman ready for love causes a scandal. Before Klimt, Edouard Manet's *Olympia* had aroused hatred and criticism. She likewise was a Nini – like the courtesan on the next street corner – rather than a Venus in the style of Titian's idealised mistresses, disguised as mythical goddesses. Neither in Manet's Paris nor in Klimt's Vienna was it permissible for such idols to be drawn from life.

Music (lithograph), 1901
"His manner of painting was baroque, but the result was Greek". Coined with regard to Franz von Stuck, this witty saying characterises Klimt as well, whose vocabulary teems with classical allusions; yet it is in bringing figures to life that his great art lies.

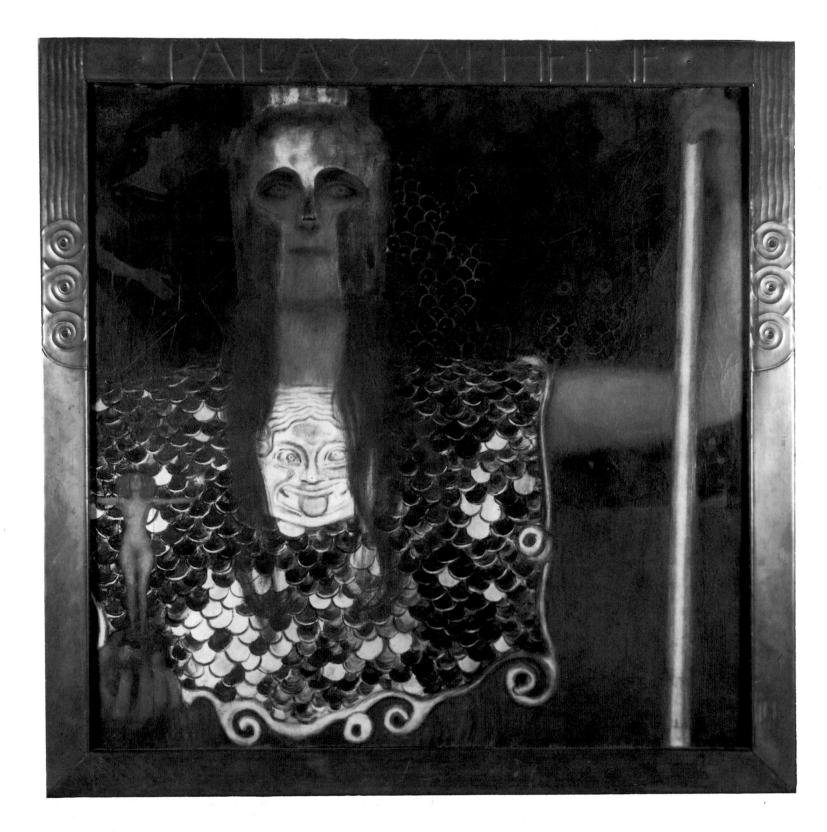

Secessionist Symbolism and Femmes Fatales

"We want to declare war on sterile routine, on rigid Byzantinism, on all forms of bad taste… Our Secession is not a fight of modern artists against old ones, but a fight for the advancement of artists as against hawkers who call themselves artists and yet have a commercial interest in hindering the flowering of art."[2] This declaration by Hermann Bahr, the spiritual father of the Secessionists, may serve as the motto for the foundation in 1897 of the Vienna Secession, with Klimt as its leading spirit and president.

The artists of the younger generation were no longer willing to accept the tutelage imposed by Academicism; they demanded to exhibit their work in a fitting place, free from "market forces". They wanted to end the cultural isolation of Vienna, to invite artists from abroad to the city and to make the works of their own members known in other countries. The Secession's programme was clearly not only an "aesthetic" contest, but also a fight for the "right to artistic creativity", for art itself; it was a matter of combatting the distinction between "great art" and "subordinate genres", between "art for the rich and art for the poor" – in brief, between "Venus" and "Nini".

In painting and in the applied arts, the Vienna Secession had a central rôle in developing and disseminating Art Nouveau as a counter-force to official Academicism and bourgeois conservatism. This rebellion of the young, in search of liberation from the constraints imposed on art by social, political and aesthetic conservatism, was accomplished with such impetus as to meet with almost immediate success and resulted in a utopian project: the transformation of society by art.

The Secession published its own journal, "Ver Sacrum", to which Klimt contributed regularly for two years. After successful exhibitions in other countries, the desire for the Secession's own exhibition building could also be fulfilled. Klimt too submitted designs for this, with a Graeco-Egyptian orientation, but it was Joseph Maria Olbrich's plans for the temple to art that were ultimately realised. His concept was of a blending of geometrical shapes, from cube to sphere. The pediment bears the famous maxim coined by Ludwig Hevesi, the art critic: "To every age its art, to art its liberty".

The group's first exhibition Swas eagerly awaited; the doors were opened in March 1898. Klimt contributed "Theseus and the Minotaur", a poster rich in symbolic meaning. The fig-leaf was deliberately missing,

Sonja Knips, 1911
Photograph: anonymous

Portrait of Sonja Knips, 1898
The portrait of this young society lady shows the expression of aloofness and disdain shared by all Klimt's *femmes fatales* from this time on. In the photograph (above), taken 13 years later, the features have become heavier.

Pallas Athene, 1898
This is Klimt's first use of gold. The voluptuous ornamentation underlines the essential erotic ingredient in his view of the world.

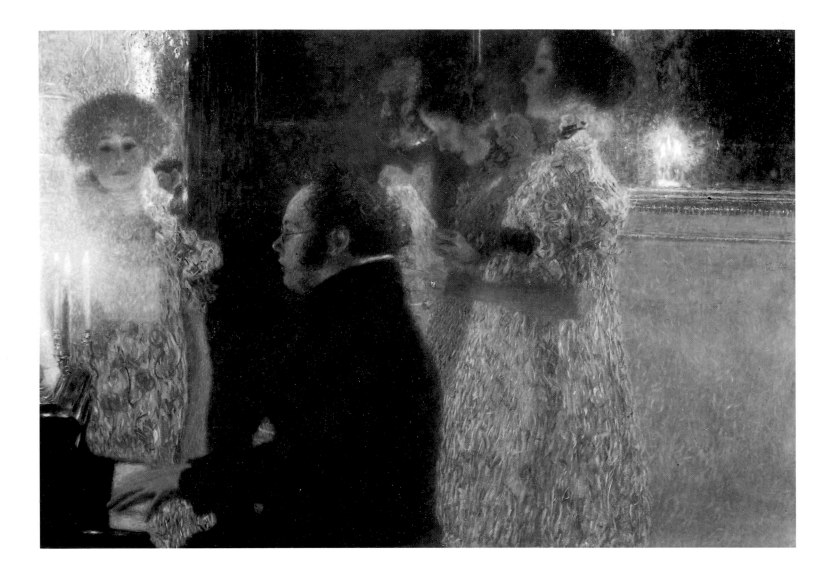

Schubert at the Piano, 1899
Klimt in the unthreatening guise admired in Vienna, with the sentimental bourgeoisie's favourite composer, to round off their delight.

Nuda Veritas, 1899
This veritable woman, 2 metres tall, expressive and provocative in her nakedness, is bewildering and challenging for the Viennese public. Her pubic hair suffices as a declaration of war on the classical ideal of beauty.

and Klimt had to appease the prudery of the censors by importing a tree. Yet the almost complete nakedness of Theseus symbolises the fight for something new; he is on the side of light, while the Minotaur, pierced through by Theseus's sword and fleeing timidly into the shadows, represents broken power. Athene, sprung from Zeus's forehead, watches over the scene as the incarnation of the spirit springing from the brain, symbolising divine wisdom.

There can be no art without patronage, and the patrons of the Secession are to be found first and foremost among the Jewish families of the Viennese bourgeoisie. Karl Wittgenstein, the steel magnate, Fritz Wärndorfer, the textile magnate, the Knips family, and the Lederers promoted especially avantgarde art. They were among those commissioning paintings from Klimt, and he specialised in portraits of their wives.

The *Portrait of Sonja Knips* (see p. 17) is the first in this new gallery of wives. The Knips family were connected with the metal industry and with banking. Josef Hoffmann designed their house and Klimt provided paintings for it, with the 1898 portrait of Sonja in the centre of the salon, and of the house. The portrait unites various styles. It is well known that Klimt admired Makart's hyperbole, and Sonja's pose shows the influence of the master's *Charlotte Walter as Messalina*, for instance in the asymmetrical positioning of the figure and in the emphasising of the silhouette. Klimt's treatment of the dress, on the other hand, is uncharacter-

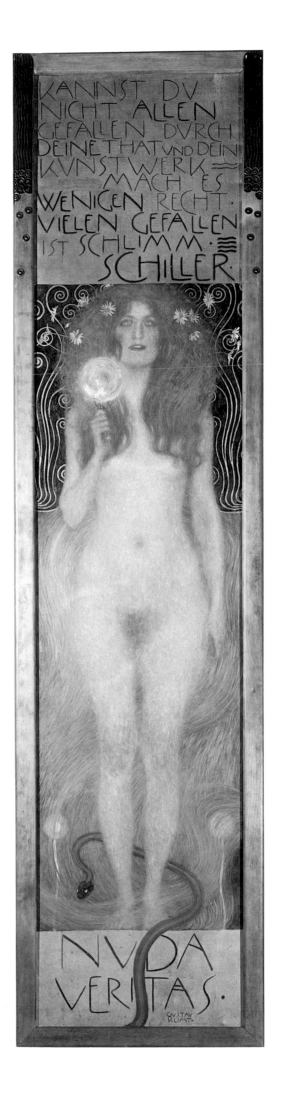

Two studies of a standing nude, 1897/98

Medicine (composition study), 1897/98
"Though you cannot please all men with your deeds and with your art, yet seek to please a few. To please the multitude is not good." To judge by the outrage provoked by Klimt's *Medicine*, it seems that he made Schiller's maxim his own.

istically reminiscent of Whistler's light brush. The proudly distant expression that he gives to this society woman is typical of Klimt; it is encountered again and again, from this time on, in his *femmes fatales*.

One of the great themes of the *fin de siècle* was the domination of woman over man. The battle of the sexes preoccupied the salons; artists and intellectuals participated in the discussions. Klimt's 1898 *Pallas Athene* (see p. 16) is the first archetypal "superwoman" in his gallery: with her armour and weapons she is sure of victory and she subjugates man, or perhaps the whole of mankind. Some elements appear in this picture which would be decisive in Klimt's subsequent work: for instance, the use of gold and the transformation of anatomy into ornamentation, of ornamentation into anatomy. Klimt remains active on the surface, unlike the younger generation of Expressionists who seek immediate penetration of the psyche. Klimt's visual language takes its symbols, both male and female, from Freud's dream world. The voluptuous ornaments reflect the

Fish Blood, 1898

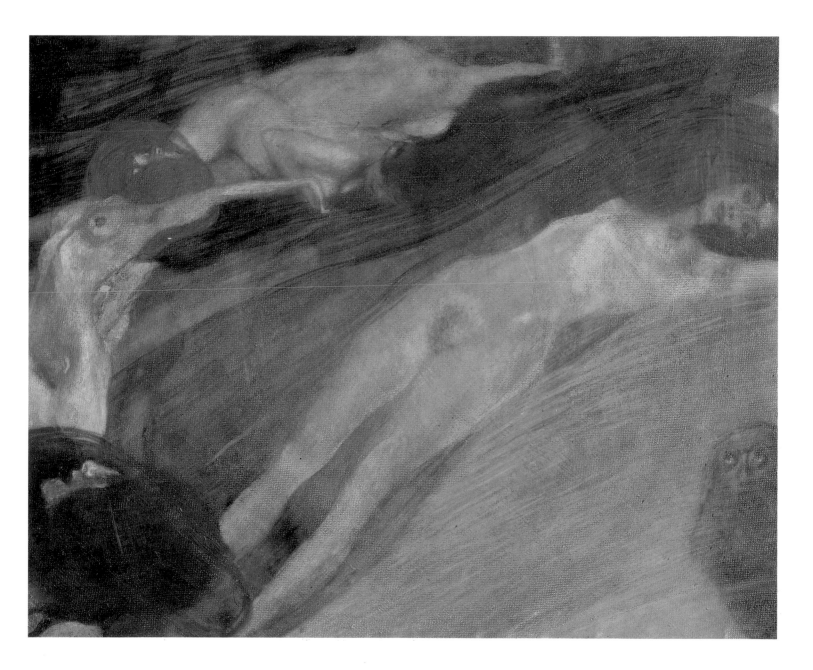

eroticism which represents one side of Klimt's visions of the world as he knew it.

This eroticism repeatedly provoked polemics, as in the case of the three designs for the Great Hall of the University. These works were widely felt to be scandalous. In 1899 Klimt presented the definitive version of *Philosophy* (see p. 22), the first of the three pictures. An earlier version had been shown for the first time at the World Exhibition in Paris. Although it was well received by many critics in Paris, and even won a prize at the exhibition, the learned authorities at home made it the object of such scandal that the whole of Viennese culture was dragged through the mud. Yet it seems that Klimt had only the best intentions. He saw *Philosophy* as the synthesis of his world view, of his search for a style of his own. In the catalogue he explains: "On the left a group of figures: the beginning of life, fruition, decay. On the right, the globe as mystery. Emerging below, a figure of light: knowledge."[3]

Moving Water, 1898
Klimt's water women yield with sensuous abandon to the embraces of the waves, their natural element.

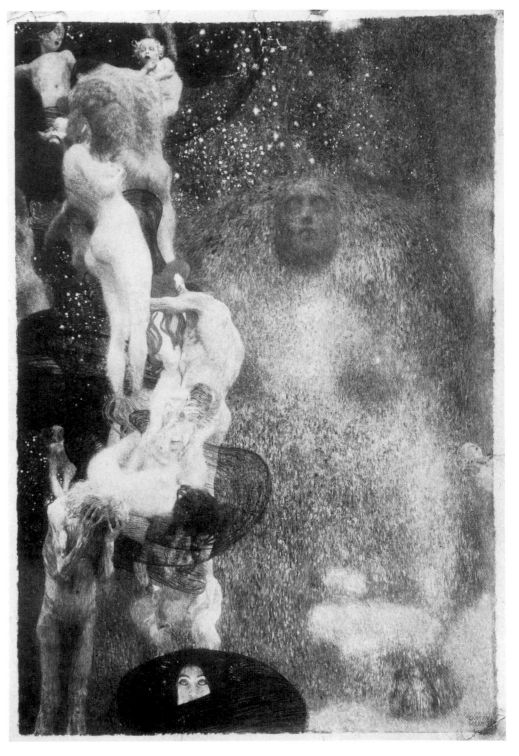

Nude study of an old man holding his head in his hands, study for *Philosophy*, 1900–07

Transfer sketch for *Philosophy*, 1900–07

Philosophy, 1899–1907
Men and women drift as in a trance, with no control over the direction they take. This contradicted the notions of science and knowledge prevailing among scholars at the time, and was felt to be a grave affront; it was the University that had commissioned these early works from Klimt.

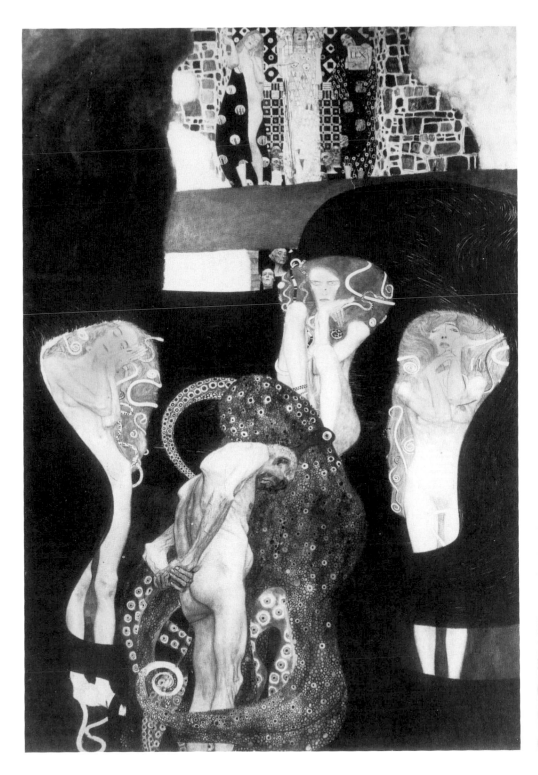

Jurisprudence, 1903–07
Instead of portraying the victory of light over
darkness, as was expected, Klimt gave expression to mankind's sense of insecurity in the
modern world.

Transfer sketch for *Jurisprudence*,
1903–07

Medicine, 1900–07
Klimt was convinced of the powerlessness of medicine as against the powers of destiny. The public was deeply perturbed; people were shocked; and the artist was charged with "pornography" and "perverted excess".

Transfer sketch for *Medicine*, 1901–07

The venerable Viennese professors protested at what they saw as an attack on orthodoxy. They had proposed a painting which would express the triumph of light over darkness. Instead the artist had presented them with a portrayal of the "victory of darkness over all". Influenced by the works of Schopenhauer and Nietzsche, trying in his own way to solve the metaphysical riddle of human existence, to give expression to modern man's confusion, Klimt inverted the proposition. He did not hesitate to break the taboo on such themes as disease, physical decay, and poverty in all its ugliness; up to this time it had been customary to sublimate reality, to present its more favourable aspects.

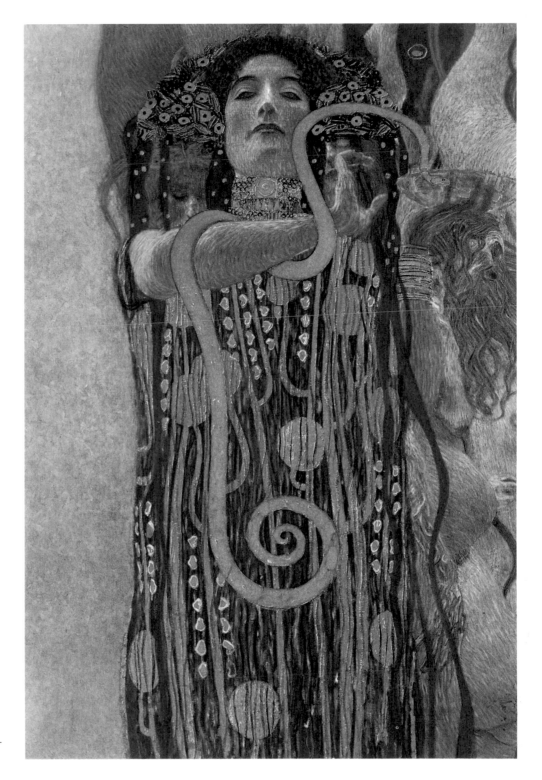

Hygieia (Detail from *Medicine*), 1900–07
Even Hygieia, goddess of health, turns her back on mankind and is more *femme fatale* and sorceress than enlightened symbol of medical science.

Life and the erotic expression of life are always concentrated on the struggle between Eros and Thanatos, and this is all-pervading in Klimt. The allegory of *Medicine*, the second of the Faculty pictures for the University, again provoked a scandal. Bodies torn away by destiny are carried onwards by the stream of life, in which all the stages of life, from birth to death, are brought together, be it in ecstasy or in pain. This vision is bound to belittle medicine; it emphasises the impotence of medicine as a healing force compared with the untamable powers of destiny. Is not *Hygieia* (see p. 25), the goddess of health, turning her back on mankind with hieratic indifference, more enigmatic or bewitching femme fatale

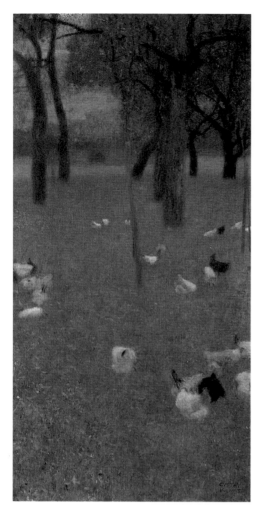

After the Rain (Garden with Chickens in St Agatha), 1899
Klimt's landscape paintings are equally important and informative. The chickens stand out in quasi-relief from the surface of the painting; as symbols of nature's fertility, they correspond to the erotic syntax of his portraits.

Nymphs (Silver fish), c. 1899
These evocative aquatic forms lead the way to a labyrinth of sexual allusions, identifiable in terms of Freud's world of symbols.

than symbol of scientific enlightenment? Are not the enchanting young female bodies intermingled with skeletons a direct illustration of Nietzsche's parable of "eternal return", in which death is seen as the cardinal point of life? In *Philosophy* and in *Medicine* Klimt is expressing a view which he shares with Schopenhauer, of "the world as will, as blind force in an eternal circle of bringing forth, loving and dying."[4]

The third work for the University, *Jurisprudence* (see p. 23), was received with equal hostility; viewers were shocked by the ugliness and nakedness they thought they saw. Only one of the academics, Franz von Wickhoff, Professor of the History of Art at the University of Vienna, defended Klimt in a legendary lecture entitled "What is ugly?" This did not prevent the scandal provoked by Klimt from being the subject of a question in Parliament. The artist was accused of "pornography" and of "perverted excess".

In the picture *Jurisprudence,* Klimt seems to be treating sexuality in a manner suggested by Freud's research into the unconscious. Klimt ventures – oh shame! – to present sexuality as a liberating force, in contrast to scientific knowledge with its constricting determinism. He had been expected to contribute to the glorification of science, but instead he seems to have taken as his motto the quotation from Virgil's "Aeneid" with which Freud prefaced his "Interpretation of Dreams": "If I cannot move the gods, I will invoke hell."

Klimt did not allow himself to be intimidated by the raucous opposition, but continued on his way. His only answer to the vehement criticism was to paint a picture, first of all called *To my critics*, later exhibited as *Goldfish* (see p. 34). The public outcry reached a tumultuous level: the lovely, frolicsome nymph in the foreground was sticking her bottom out at all who beheld her! The aquatic figures entice the viewer into a world of sexual evocations and associations comparable to Freud's world of symbols. This world had already been glimpsed in *Moving Water* (see p. 21) and *Nymphs (Silver fish)* (see p. 27), and would be found again some years later in *Water Serpents I* (see p. 46) and *Water Serpents II* (see p. 47). Art Nouveau loves the realm of water, where dark and light algae grow on Venus molluscs, or delicate tropical coral flesh shimmers between bivalve lamellae. The semiotics lead us back to their incontrovertible origin: woman. In these watery dreams, algae become hair growing from head and pubis. Klimt's "fish-women" put their humid sensuality unashamedly on display. They follow the tide with the curvilinear movements so characteristic of Art Nouveau. In languid provocation, they yield to the embraces of the watery element, just as *Danae* (see p. 64) lies open to Zeus in the form of a shower of gold.

Klimt's portraits of society wives gave him financial independence, so that he was not obliged to fall into line with ministerial demands or watch his painstakingly thought out and brilliantly executed works dragged through the mud. He suggested that they should be returned to him in exchange for the payments that had already been made. He explained to Bertha Zuckerkandl, the Viennese journalist: "The main reasons for my deciding to ask for the paintings to be returned... do not lie in any annoyance that the various attacks... might have aroused in me. All that had very little effect on me at the time, and would not have taken away the

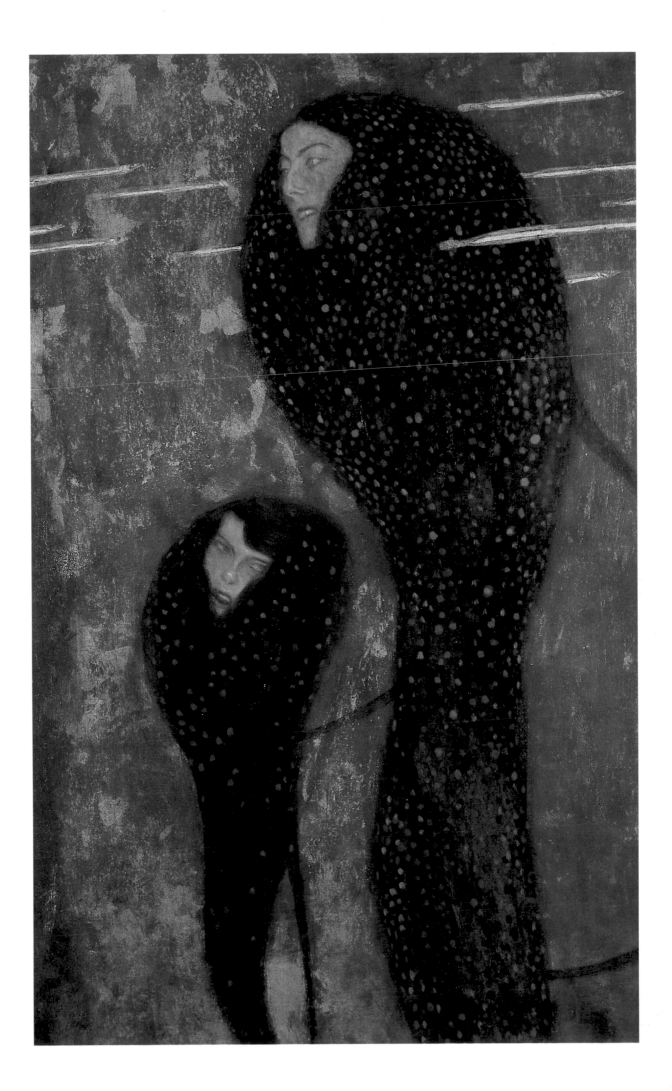

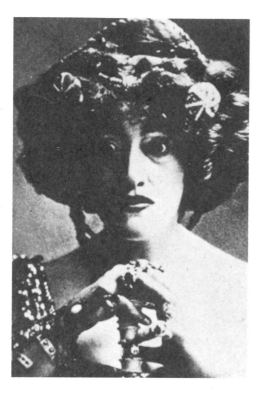

Anna Bahr-Mildenberg as Clytemnestra in "Electra" by Richard Strauss, 1909

Judith I, 1901
The association of sexuality and death, Eros and Thanatos, fascinated not only Klimt and Freud but also the whole of Europe at the time; a shuddering public was gripped by the spectacle of Clytemnestra's blood lust in the opera by Richard Strauss.

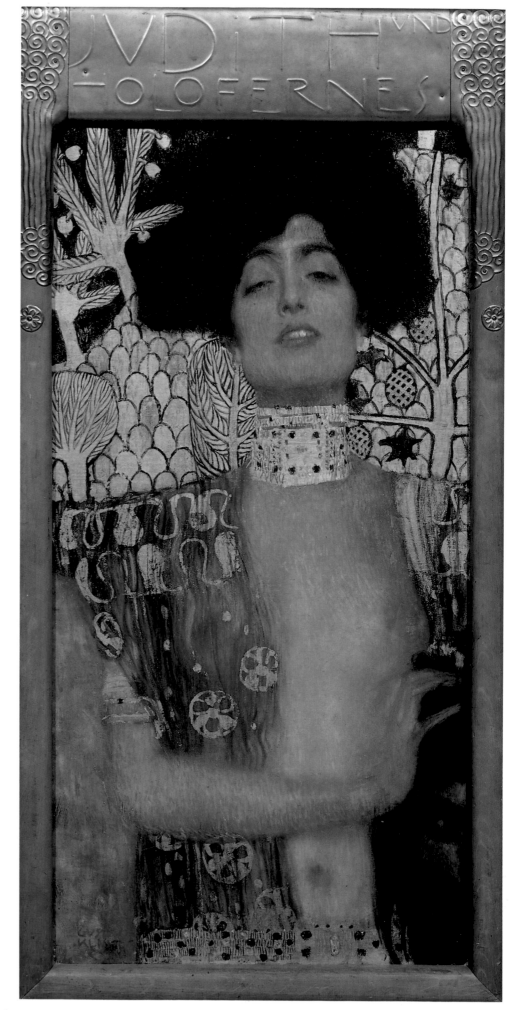

joy I felt in this work. I am in general very insensitive to attacks. But I am all the more sensitive if I come to feel that somone who has commissioned my work is not satisfied with it. And that is the case with the ceiling paintings."[5] The ministry finally agreed, and the industrialist August Lederer made part of the repayment in exchange for the picture of *Philosophy*. In 1907, Koloman Moser purchased *Medicine* and *Jurisprudence*. In an attempt to save them from the dangers of World War II, they were moved to Schloß Immendorf in the south of Austria; the castle and its contents were destroyed in a fire started by retreating SS troops on 5 May 1945. Today, some idea of the works which caused such public outrage can be gained from black-and-white photographs and from a good colour reproduction of *Hygieia*, the central figure of *Medicine*. There is also the "colourful" commentary by Ludwig Hevesi: "Let the gaze move to the two lateral pieces, *Philosophy* and *Medicine*: a mystic symphony in green, a rousing overture in red, a purely decorative play of colours in both. In *Jurisprudence,* black and gold, not actual colours, prevail; instead of colour, the line gains significance, and form becomes a characteristic that one must regard as monumental."[6]

Klimt's work was created in the turbulence between Eros and Thanatos, challenging the sacrosanct principles of a decadent society. In *Philosophy* he depicted the triumph of darkness over light, in contrast with conventional notions. In *Medicine* he exposed its inability to cure disease. Finally, in *Jurisprudence,* he portrayed a condemned man in the power of three Furies: Truth, Justice and Law. They appear as the Eumenides surrounded by serpents; the punishment they impose is an octopod's deadly embrace. Klimt was determined to bring down the pillars of the temple and to wound the prudish by his portrayal of sexual archetypes.

Nothing survives from this deliberately conducted campaign except the tangible evidence of photographs and one partial reproduction of the vanished masterpieces – and the bitter recognition of the impotence of the artist pilloried by censorship. Klimt was never to become professor at the Academy; but before those who mocked him he held up the mirror of "naked truth" – *Nuda Veritas* (see p. 19).

"To art its liberty", wrote Hevesi on the pediment of the Secession House. Klimt wanted to be completely free, wanted to think and paint without being dependent on official commissions, and in this he received the support of several loyal patrons. Before the Vienna University scandal he had met Nikolaus Dumba, the son of a Greek businessman from Macedonia with contacts in the Orient, who had made a fortune in banking and the textile industry. The interior decoration of his office had been done by Hans Makart. After Makart's death, Klimt became Dumba's most favoured artist. It was to him that the furnishing, accessories and decoration of the music salon in the Nikolaus Dumba Palais were entrusted. This included two supraportal pictures, the first of which shows *Schubert at the Piano* (see p. 18), while the second, *Music II*, is of a Greek priestess with Apolline cithara. The first harks back nostalgically to the lost paradise of a well-placed, carefree society that enjoyed the diversions of music in the home. The second is quite different in style and points the way to a world of symbols expressed by the Dionysian

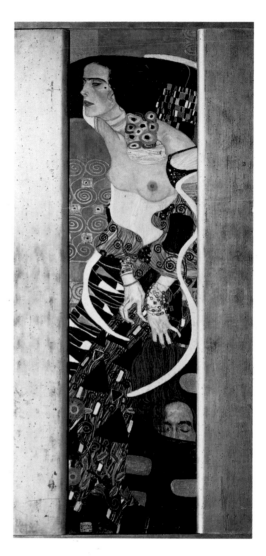

Judith II (Salome), 1909
Judith or Salome? Klimt was patently painting the "murderous orgasm" of the *femme fatale*, rather than the portrait of the virtuous Jewish widow.

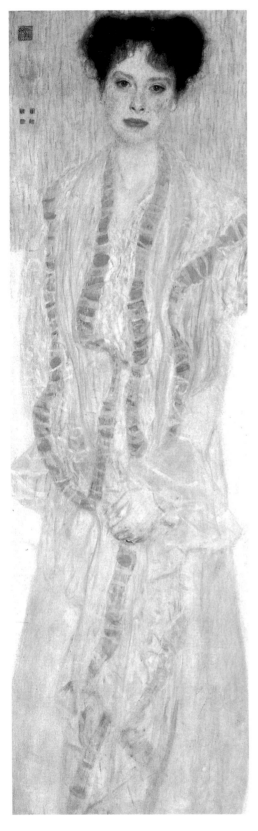

Portrait of Gertha Felsöványi, 1902

Portrait of Serena Lederer, 1899
Klimt knew how to appeal to the prosperous Jewish citizens of Vienna, who supported the Secession; he painted their wives with a full measure of charm, and with a trace of haughtiness.

power of music. "In these two pictures", wrote Carl E. Schorske, "bourgeois serenity and Dionysian unrest confronted one another in a single room. The Schubert picture shows music-making in the home, with music as the artistic high point of a secure and well-ordered way of life. The scene glows in a warm candlelight that softens the outlines of the figures, so that they melt into convivial harmony... Klimt makes use of Impressionist techniques in order to replace historical reconstruction by nostalgic evocation. He presents us with a lovely dream, glowing but incorporeal – the dream of innocent, pleasure-giving art in the service of an untroubled society."[7]

This was the Klimt whom Vienna loved, an unthreatening Klimt who enchanted even the most conservative public, rewarding their applause by giving them even more than they had expected – the composer Schubert, hallowed object of their sentimental veneration. Klimt reserved his most flattering style for his patrons in Viennese society. This was evident in his *Portrait of Sonja Knips* (see p. 17), and is evident also in the gentleness of the subsequent "wives" portraits, of *Gertha Felsöványi* (see p. 30) or *Serena Lederer* (see p. 31), and in *Emilie Flöge* (see p. 32). Yet the women in these portraits always have the same serene air of reverie: they look at the world, and at man, with a sense of melancholy but also of detachment. Klimt's "horror vacui" is intensely concentrated in their monumental presence. His eclecticism allows him to draw now on Velasquez, now on Fernand Khnopff. From the one he takes the manner of painting the bouffant hair-style and the contours of the chin; from the other, certain characteristics of the *femme fatale*. There is invariably something crushing in the apparent passivity of his subjects.

Whenever Klimt was not working for a patron, he seemed to throw off all restraint and paint as he truly willed. A quite different type of woman entered the picture, dangerous and instinctual, as in *Pallas Athene* and *Nuda Veritas*. Appearing first in the design for "Ver Sacrum", she therefore became known as the "daemon of the Secession". The second version, an oilpainting 2.6 metres high (see p. 19), marked the breakthrough of Klimt's new "naturalistic" style. The public was shocked and confused by the provocative red-headed nude with red-haired pubis, no Venus but a larger-than-life Nini, a creature of flesh and blood severing the links with the traditional idealisation of female nudity in art. The pubic hair alone was a declaration of war on the classical ideal. The Schiller quotation served as commentary, reinforcing the provocation and pre-empting the ensuing public rejection: "Though you cannot please all men with your deeds and with your art, yet seek to please a few. To please the multitude is not good." The first version, published in "Ver Sacrum", was headed by an equally élitist quotation, from L. Scheffer: "True art is created by a few, to be appreciated by a few."

Judith I and, eight years later, *Judith II* are further realisations of Klimt's archetypal *femme fatale*. His Judith is no biblical heroine, but rather a typical Viennese of his own epoch, as demonstrated by her fashionable if costly dog-collar necklace. According to Bertha Zuckerkandl, Klimt was creating a type of woman comparable to Greta Garbo or Marlene Dietrich, long before these women came to fame (and before the term "vamp" achieved common currency). Proud and dismissive, yet

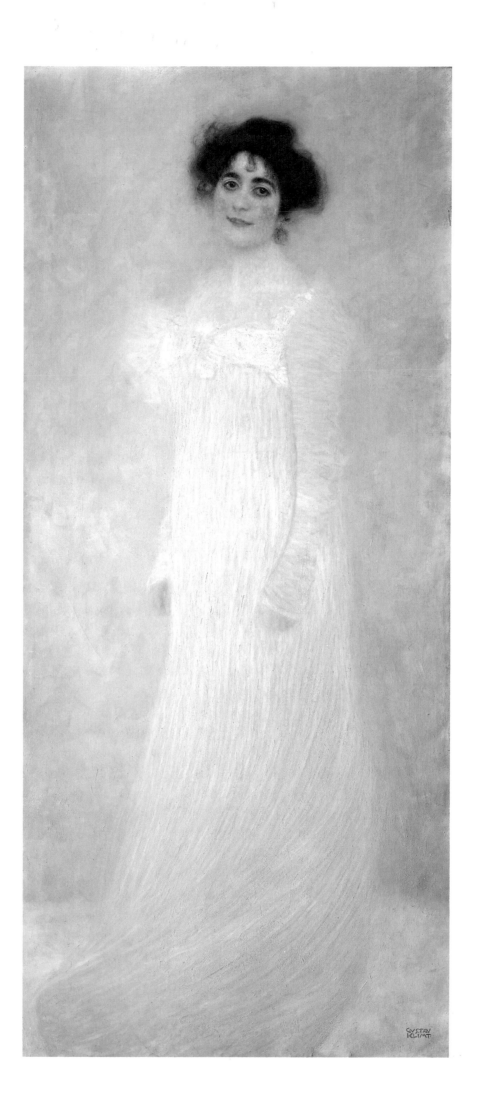

Emilie Flöge, 1902
Photograph: Ora Branda

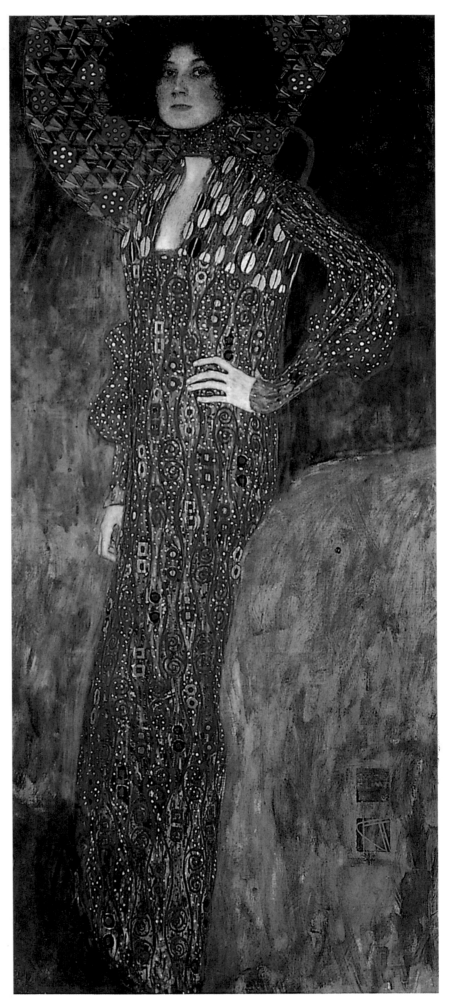

Portrait of Emilie Flöge, 1902
Emilie Flöge was Klimt's great love, his companion to the end of his life. She ran a fashion house, and he designed materials and dresses for her. His patterns looked as if they had been cut from the background of his landscape paintings.

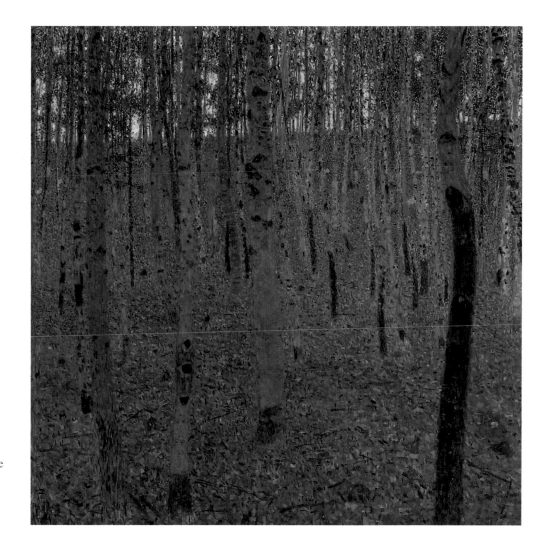

Beech Forest, 1902
Klimt brings to his landscape paintings the same sensuousness that one finds in his portraits. He applies to the rich tapestry effect an element of eurhythmic spirituality, with recurrent vertical and horizontal groupings.

at the same time mysterious and bewitching, the *femme fatale* casts her spell over the – male – observer.

The pictures cannot be viewed independently of the gilded frames that give them an iconic quality. The frame of the first version was made, incidentally, by Klimt's brother Georg, a goldsmith. The ornamentation of the painting is carried over into the frame in a manner very popular at the time which had been developed by the Pre-Raphaelites. The pictures also show the influence of the Byzantine art which Klimt had seen on a journey to Ravenna. The deliberate contrast between the plasticity of the finely modelled and coloured face and the two-dimensional surface of the ornamentation is a distinctive feature of these pictures; it creates an effect almost of photomontage, and contributes greatly to their charm. The figures on the van Eyck brothers' Ghent altar are often cited as formal precursors.

Without doubt, Klimt found in Judith a compelling symbol for justice wrought by woman on man, whose atonement is in death. In order to save her city, Judith seduced Holofernes, the enemy general, and then cut off his head. The Old Testament heroine is the perfect example of courage and decisiveness serving an ideal, the castrating woman... In this biblical figure, Eros and death are united in the familiar conjunction which the *fin de siècle* found so intriguing, another example of the castrating woman, with shameless power to confirm the most perverse fantasies, being Richard Strauss's "Mycenaean ruler", bloodthirsty Clytemnestra.

Goldfish, 1901/02
This picture is Klimt's reply to the sharp criticism of his Faculty paintings. Entitled at first "To my critics", the picture shows in the foreground a wonderful laughing naiad who is frankly turning her beautiful bottom in the direction of the viewer.

Klimt's Judith was bound to antagonise a section of Viennese society which was otherwise willing to accept his infringements of taboos, namely the Jewish bourgeoisie. This time he was breaking a religious taboo, and the viewers could not believe their eyes. Commentators opined that Klimt must have been mistaken in his claim that this ecstatic, indeed orgasmic, woman with her half-closed eyes and lightly parted lips was the devout Jewish widow and courageous heroine, who with never a trace of pleasure had executed the terrible mission assigned her by heaven and beheaded the dastardly Holofernes, leader of the Assyrian army. Surely, people said, Klimt must have been thinking of Salome, the typical *femme fatale* of the *fin de siècle*, who had already fascinated so many contemporary artists and intellectuals, from Gustave Moreau to Oscar Wilde, Aubrey Beardsley, Franz von Stuck and Max Klinger. Well-meaning souls repeatedly listed the "Judith" pictures under the title "Salome" in catalogues and journals. Whether or not Klimt did actually assign to his Judith the characteristics of Salome remains uncertain; whatever his intentions, the result was the most eloquent representative of Eros and of the fantasies of a modern *femme fatale*.

Yet Klimt was not only familiar with the *femme fatale*. While his compositions for the Great Hall of the University were still causing a stir, he, cultivating his garden like a latter-day Candide, turned his attention to landscape painting, taking as his starting-point the Impressionist and Post-Impressionist landscapes. There could be good grounds for seeing Monet as the model for some of Klimt's early landscape paintings, such as *The Marsh* (1900) or *Tall Poplars II* (1903). As a landscape painter, however, Klimt offers a bold synthesis of Impressionism and Symbolism. The brush strokes of the dissolving forms are reminiscent of the Impressionists, but the schematisation of surfaces, often displaying the influence of the Orient, is typical of Art Nouveau. Unlike the Impressionists, Klimt shows little interest in weather, in the play of light and shadow. As in his portraits, he constructs enamelled mosaics, combining naturalism with schematism. This is evident when one compares such pictures as *After the Rain* (see p. 26), *Nymphs* (see p. 27) or the *Portrait of Emilie Flöge* (see p. 32) with *Beech Forest* (see p. 33): in his landscape paintings, as in his portraits and allegories, figures and shapes appear as it were in relief against a setting of planar ornamentation.

The forest scenes, such as *Beech Forest* (see p. 33) or *Beech Forest I* (see p. 35), resemble a tapestry in which Klimt invokes a kind of eurhythmic spirit, creating recurrent patterns with grouped vertical and horizontal lines. Van Gogh assisted the breakthrough of modern painting with all the power of despair, whereas Klimt was more a silent harvester, the sensuous shimmer of his landscapes enhancing their floral ornamentation and symbolic signification. The diverse mosaics that swallow up the horizon and negate space offered relief from the "horror vacui" that tormented him.

The fact that his landscapes show no sign of people helps us to understand that Klimt actually treats them as living beings, and since woman is the chief protagonist in his work, we may conclude that he treats his landscapes as women. Does not the gown worn by Emilie Flöge in the first 1902 portrait (see p. 32, right) look as if the material has been cut from

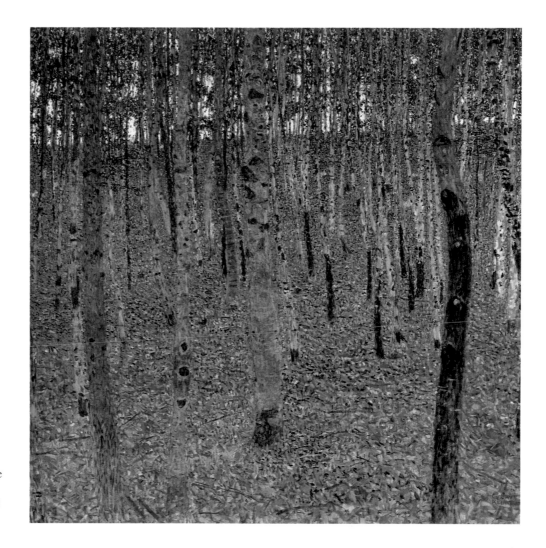

Beech Forest I, c. 1902
Van Gogh's trees burst upon the world, a fanfare of modern painting, whereas Klimt gathers nectar in silence and brings a sensuous shiver to his trees: he treats them as he treats women.

one of these forests, to cling to her like a second skin? Klimt chose this gown so that her slender silhouette might appear to full advantage; small wonder then that it almost gave rise to another scandal in Vienna. Even his mother protested at the newfangled dress that was so very out of line with the frills and flounces currently in vogue.

In Klimt's portraits, the dress is no less important than the model. In a subtle way it serves to unveil the woman's personality, heightening the effect of face, neck and hands. Ingres may be seen as a classical precedent; his portraits likewise give full expression to sensuousness. For both artists, clothes have the same essential function as bodily organs, or rather, they become organs. Gaëtan Picon's comment on Ingres could be applied equally well to Klimt: "Nothing is more sharply, more subtly Ingres than the harmony of neck and necklace, of velvet and flesh, of shawl and coiffure; or the line in which breast encounters low-cut gown, arm encounters elbow-length glove. If these portraits of women have an especial glow, it is because they emanate from the radiance of desire; they come to us in covert nakedness…"

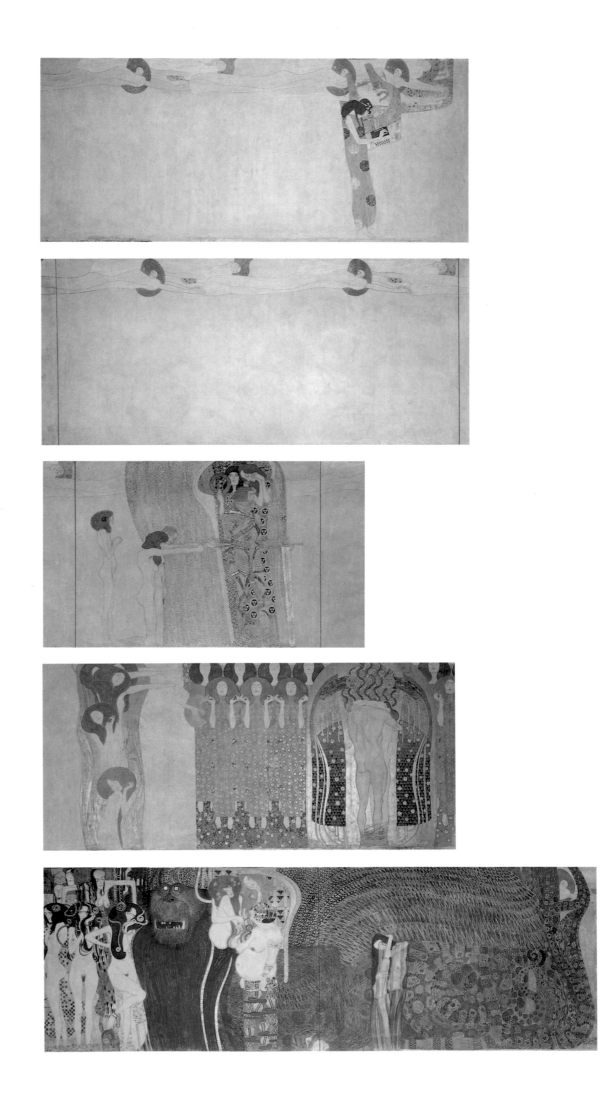

The Hymn to Joy and the Beethoven Frieze

For Gustav Klimt, philosophy, medicine and jurisprudence did not seem to guarantee a happy or fulfilled life for any man, as was made clear in his Faculty paintings for the University. He and his fellow Utopians saw art, and art alone, as having the power to bring salvation, which explains the particular importance that the Secessionists attached to the total work of art.

In this spirit they determined to make their fourteenth exhibition a special event and experience – a total work of art. The exhibition was mounted in 1902, in honour of Max Klinger, whose Beethoven sculpture formed the centrepiece. The whole exhibition became a Beethoven celebration. The composer was something of a cult figure at the time, public enthusiasm having been fired by Franz Liszt's and Richard Wagner's reverential admiration of him. At the same time, in France, Bourdelle was making his great Beethoven mask and Romain Rolland writing his "Life of Beethoven". Klimt and his friends saw in Beethoven the incarnation of genius, and in his work the glorification of love and of the sacrifice that can bring redemption to mankind.

Klinger's statue is of a heroic Beethoven. There is a sacral quality in it, reminiscent of Phidias' "Zeus". The heroically naked stance of the martyr and redeemer, with clenched fist and upward-turning gaze, gives a perfect indication of the Secessionists' intentions.

Josef Hoffmann was responsible for the interior decoration of the Secession House for the exhibition. He used bare concrete in order to create as neutral a setting as possible. Furthermore, a total synaesthetic experience was planned, which included music: the fourth movement of Beethoven's Ninth Symphony was performed, in a new orchestration for woodwind and brass conducted by the Vienna Opera's then musical director, Gustav Mahler.

Finally, Klimt created his Beethoven Frieze for this exhibition. He intended that it should last only for the duration of the exhibition and therefore applied it directly to the walls, using light materials so that it could easily be taken down again. Fortunately it was preserved, although for decades it was not on show to the public; not until 1986 did it become possible to view it once more. The frieze has therefore remained the least known, and the most mythologised, of Klimt's works. He himself clearly saw it as a symbolic transposition of Beethoven's last symphony.

The exhibition catalogue is informative in this respect: "The paintings

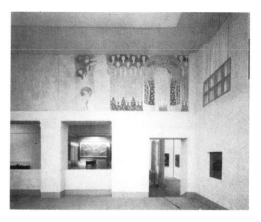

Reconstruction of the Klimt room, from plans drawn up in the studio of Professor Hans Hollein; right side wall.
Photograph: Hans Riha

Beethoven Frieze, 1902
A tribute to the genius whose music is to be the salvation of the soul of mankind, Klimt's frieze is based on Beethoven's Ninth Symphony. It comprises three parts: "Yearning for Happiness" encounters "Hostile Forces", but finally triumphs with the "Hymn to Joy".

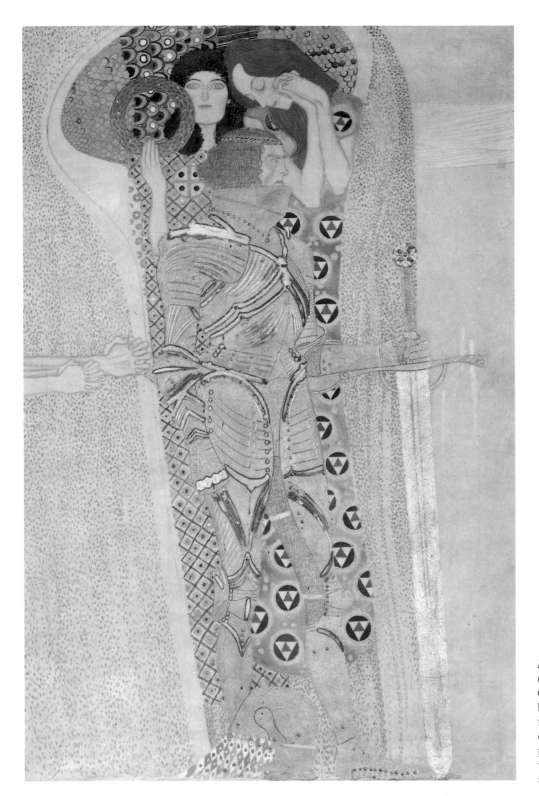

Beethoven Frieze: Yearning for Happiness (detail), 1902
Group of the Well-Armed Strong One, with Ambition and Compassion. Prayers are the extrinsic forces brought to bear on the well-armed strong one by weak, suffering humanity, whereas compassion and ambition are the intrinsic forces which impel him to take upon himself the struggle for happiness.

which extend like a frieze along the upper half of three walls in this room are by Gustav Klimt. Materials: casein paint, stucco, gilt. Decorative principle: consideration of the layout of the room, ornamented plaster surfaces. The three painted walls form a sequence. First long wall, opposite the entrance: the yearning for happiness; the sufferings of weak mankind; their petition to the well-armed strong one, to take up the struggle for happiness, impelled by motives of compassion and ambition. End wall: the hostile forces; Typhoeus the giant, against whom even gods fought in vain; his daughters, the three Gorgons, who symbolise

Beethoven Frieze: Hostile Forces (detail), 1902
From the panel dedicated to "Hostile Forces": the three Gorgons – Disease, Madness and Death.

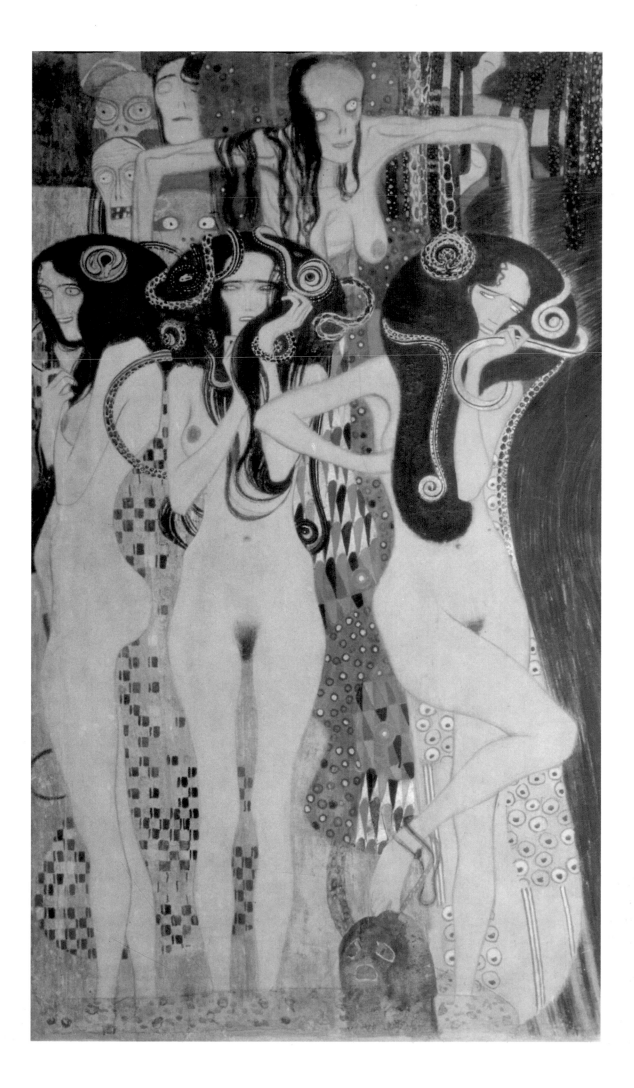

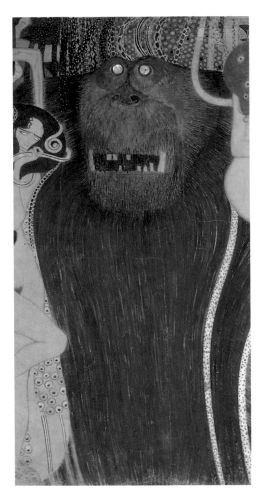

Beethoven Frieze: Hostile Forces (detail), 1902
The giant Typhoeus, a hideous ape with serpent's tail and wings, terrifying antagonist of the gods.

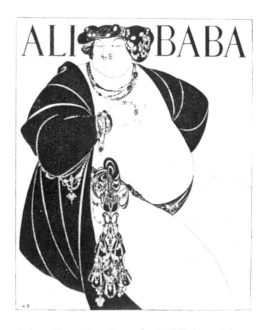

Aubrey Beardsley: Cover for "Ali Baba and the Forty Thieves", 1897
Beardsley and Klimt share a taste for the most extravagantly elaborate and super-refined ornamentation.

Beethoven Frieze: Hostile Forces (detail), 1902

lust and lechery, intemperance and gnawing care. The longings and wishes of mankind fly over their heads. Second long wall: the yearning for happiness is assuaged in poetry. The arts lead us to the ideal realm in which we all can find pure joy, pure happiness, pure love. Choir of angels from Paradise. 'Joy, lovely spark of heaven's fire, this embrace for all the world.'"[8]

For a long time, Klimt had been seeking an answer to the ultimate questions of human existence. In the three University paintings, a negative answer had emerged: philosophy, medicine and jurisprudence were found wanting; resignation and melancholy were expressed in consequence. Now, however, Klimt had found the way to a utopian vision on a grand scale, which was shared by the other Secessionists: the salvation of mankind through the unique power of art and of love.

Yet his frieze met with embattled rejection. He was criticised for being bloodless and rigid. The figures were considered repellent. The three Gorgons, allegorising a lack of chastity, purity and temperance, caused a particularly vehement outcry, since this part of the frieze was strewn with male and female genitalia, spermatozoa and ovules. Most visitors were repelled by this, though a few were drawn to it; financially, the exhibition was a disaster.

One possible explanation for public reaction to the frieze may lie in the enhanced independence of form, line and ornamentation; in achieving this, Klimt was taking a decisive step towards Modernism. This sovereignty means that form is no longer subordinate to content; rather, it develops a life of its own, with its own content. It was difficult for the public to grasp the optimistic, utopian import of the frieze, in which the final embrace signifies the redemption of man by woman. Instead, people tended to see only what was immediately obvious, such as the ugliness of some of the female figures.

In his study of Klimt's "Beethoven", Jean-Paul Bouillon argued that there was no real liberation in the sexuality thus unveiled. "On the contrary, the goal he reaches is a double nightmare: that of the castrating woman, whose sword is no longer the symbolic one of *Judith I* (1901) but her own sex; and that of the lechery of woman, whose arousal of pleasure, being self-directed (see *Lust* and many of Klimt's erotic drawings), threatens man. The first appears in the central panel in the shape of three Gorgons... (see p.41); the same three figures appear in *Jurisprudence* (see p.23), with their victim, where they show very clearly what lies in store for the voyeur disguised as viewer. The second forms part of the symmetrical group beside Typhea and further on, somewhat more fully, in *Gnawing Care*, which includes an allusion to the syphilis which Klimt is known to have particularly feared... The child-woman with her perverse, polymorphic sexuality, whose portrait Freud drew in his 'Three Essays on the Theory of Sexuality' (1905), is all the more disquieting because of her self-sufficiency: there is no place for man in this central panel."

Man is singularly absent in most of Klimt's work, his rare appearances serving only to heighten the impact of woman. In turn-of-the-century Vienna, man was evidently threatened from all sides, and was more or less excluded from what was a woman's world dominated by woman.

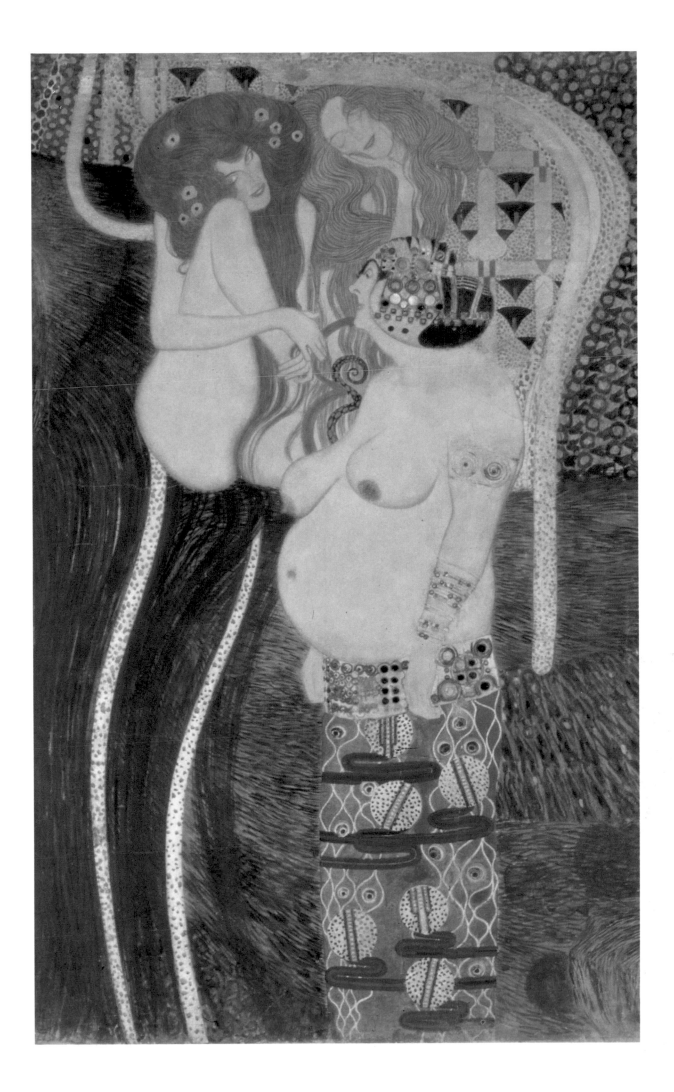

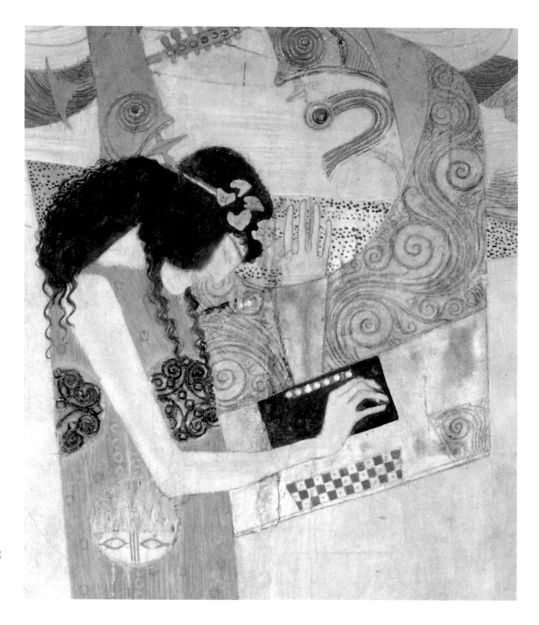

Beethoven Frieze: Hymn to Joy (detail), 1902
Wagner's commentary on Beethoven's Ninth
Symphony seems to prefigure Klimt's approach
to the work: it is "a combat of the soul struggling
to attain joy against the pressure of those hostile
forces that intervene between ourselves and
earthly happiness".

The narcissistic world of lesbian love, depicted in the flowing streams of
Water Serpents I (see p. 46 right) and *Water Serpents II* (see p. 47), exemplifies the terrifying dream of a female-dominated universe. Even the
Beethoven hero at the end of the frieze, in "This embrace for all the
world", finds himself perilously situated, naked, without armour. In spite
of his athlete's body, he is, as Jean-Paul Bouillon points out, held
prisoner by the woman's arms, which embrace him and hold down his
head. Nothing remains of the triumphant Theseus of the Secession poster.
The hero turns his back on the castrating Furies; his stance is that of the
helpless old man in *Jurisprudence*. In him we see the ambivalence of sexuality as punishment and fulfilment (C.E. Schorske).

It is the return of the hero to his mother's womb, the end of his journey
to a womb he should never have left, the last embrace, signifying also a

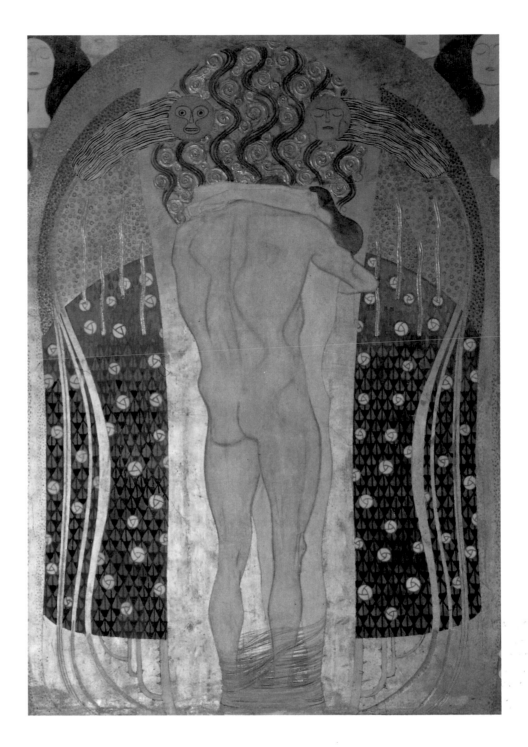

return to the source, to the cosmos in which woman is the true conqueror. This "imprisonment in the womb" is to be found again in *Hope I* (see p. 44 right), in the magnificent belly that dominates everything like "a living vessel in which the hope of mankind is ripening". This intensely lyrical vision of the pregnant woman in *Hope I* is set in an ambiguous context peopled with masks, death's-heads, and allegorical monsters such as sin, disease, poverty and death, all threatening the incipient life. Assuredly the title of the picture and the shameless body are the epitome of perfect womanhood, a hymn to life and to the flesh. But are not the surrounding elements also images of night and death? Klimt invokes the full range of his erotic vocabulary, from the motifs of penetration in symbolic relation to the protruding belly, to the mildly perverse red hair, suggestive of Hans Baldung Grien. Nothing is there to remind us of the purity of Botti-

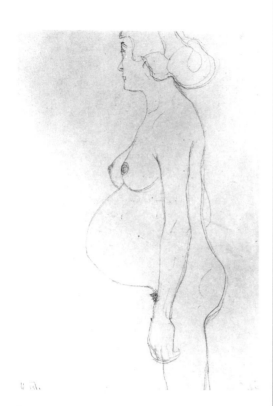

Pregnant nude standing, left profile, 1904/05

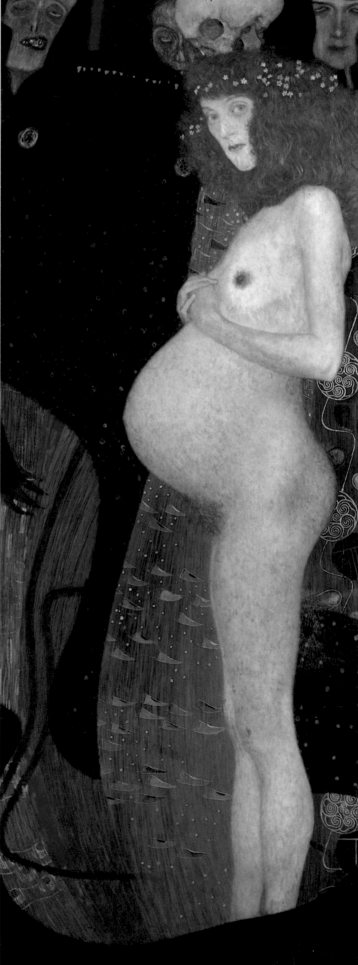

Hope I, 1903
Here is Klimt's erotic vocabulary in its totality, from shameless body, through perverse nuances of red head and red hair at the pubis, to the symbolic motifs of penetration resonating with the protruding belly. Around this picture of consummate femaleness appear elements of night and of death.

Three pregnant nudes, left profile, 1903/04

Hope II, 1907/08
Several years separate the two versions of pregnant womanhood, hymns to life and to carnality. The later of the two paintings reveals a more rational, or perhaps a more hypocritical, Klimt. The aggressive or morbid elements have vanished; only the triumphant woman in full bloom remains. Klimt has apparently made the transition from Hans Baldung Grien to Botticelli...

celli's *Spring* except the little garland of flowers in the hair. Once again, the painting was far too naturalistic and direct to be received by Klimt's contemporaries without causing a shock; inevitably they found it obscene. For a long time it remained in penitential obscurity in the private collection of Fritz Wärndorfer, where it was enclosed by two folding shutters like an altar, which emphasised its sacral character. Not until 1909 was the picture liberated, for an exhibition.

In 1902, Auguste Rodin visited the Beethoven Exhibition and congratulated Klimt on his "so tragic and so divine" frieze. The French sculptor had been exhibiting his work in Vienna since 1882, and was well known there. The artists' feelings were mutual. Klimt had already expressed his admiration in borrowing the two despairing figures from Rodin's "Gates of Hell" for *Philosophy*, placing them head in hand at the bottom of the column of mankind. *The Three Ages of Woman* (see p. 48 left) again drew on Rodin for inspiration, this time on *Celle qui fut la belle Heaulmière* ("She who was once the beautiful wife of the helmet-maker", see p. 48 right). Like *Hope*, to which it is closely related, this painting evokes humanity, destiny, the ages, and the central role of woman, but also cosmic eternity and the fusion of the sexes. The language is rich in biological ornamentation, including motifs of penetration and penetrability. Microcosm and macrocosm merge in richly allusive mosaics and a flood of colours.

Composition sketch for *Water Serpents I*,
1903–07

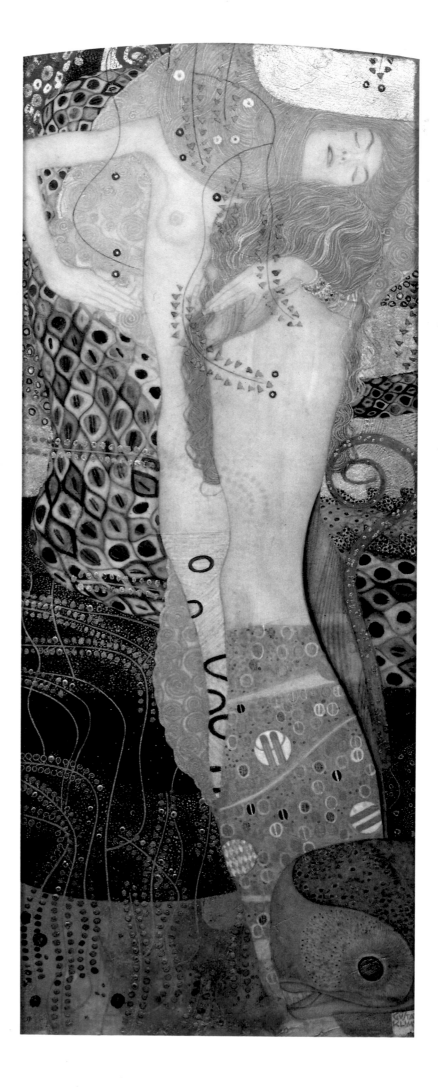

Water Serpents I, 1904–07

Faced with a society in which death and sexuality were regarded as elements of chaos and therefore inadmissible, Klimt seemed from this time on to be destined more than ever to be engaged in an arduous, feverish, turbulent and fearful quest, in search of answers to the ultimate questions of human existence. According to Georges Bataille, authentic art is inevitably promethean. Klimt's whole work is informed by symbols of human revolt against the tyranny of matter, by a striving towards the true and the ideal. Was not the reign of justice instituted by Zeus himself, in extending grace and forgiveness to Prometheus?

Lacking the magnanimity of Zeus, Vienna could not pardon Klimt. He fell from favour with officialdom, and received no further public commission. Within the Secession itself, the negative public response to the Beethoven Frieze caused conflict between Klimt's supporters and his critics. Surrounded by loyal friends such as Carl Moll, Josef Hoffmann, Koloman Moser and Otto Wagner, Gustav Klimt chose to leave the Secession, which never recovered from this loss; its great days were over. "Ver Sacrum" had to cease publication. Klimt felt the need to withdraw from the public arena. The central theme of his work continued to be the life cycle, involving procreation, pregnancy and birth, but also disease, fear of old age, and death. His setbacks lessened his attentiveness to social problems and rendered him indifferent to politics. The spiritual quest concerned him as much as ever; from a blend of occultism and oriental religions, he evolved a philosophy centred on the perennial questions of life. Eros and Thanatos were always the source of his inspiration, even though, from this time on, they usually appear in the guise of two simple and fundamental themes, flowers and women. These themes offered him

Water Serpents II, 1904–07
Klimt undoubtedly preferred to paint women rather than men; the latter are remarkably rare in his paintings. He even paints an entirely feminised universe, a narcissistic world of lesbians loving one another in flowing water dreams, their hair entangled with algae.

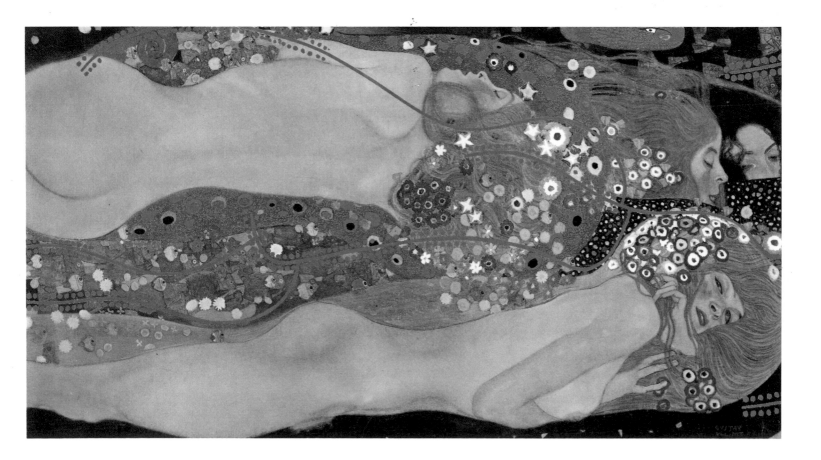

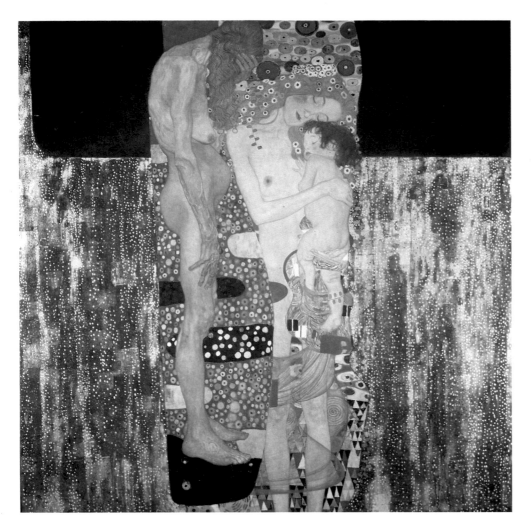

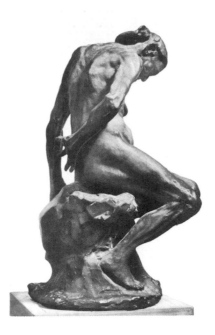

The Three Ages of Woman, 1905
Rodin visited the Beethoven exhibition in 1902, and congratulated Klimt on his "tragic and divine" frieze; Klimt in turn drew his "Three Ages of Woman" from the French sculptor's "Gates of Hell". Their admiration was mutual.

the greatest opportunity to give a certain permanence to all that can be grasped in passing: an ephemeral sensual joy, the ecstasy of life.

Foremost among these pictures were the portraits of "wives and maidens" which gave Klimt financial independence, such as the *Portrait of Margaret Stonborough-Wittgenstein* (see p. 49), which her father commissioned on the eve of her marriage to Stonborough. One cannot help wondering whether the lovely Margaret posed for Klimt in the nude, before he clothed her in the long wedding dress in the style of Whistler or Khnopff, and gently laid the elaborately embroidered floral stole in matching tones of white around her. Margaret was a strong, very avant-garde personality, a friend of Freud and a member of Vienna's intellectual and cultural élite. The sister of Wittgenstein, the ascetic philosopher, she was undaunted by any sort of game. Nor did she lack a sense of humour, shown by the fact that she positioned the portrait in the centre of her "logically conceived house", entirely white and consisting solely of cubes, that her brother had designed for her in the spirit of Adolf Loos, in opposition to the "scourge of ornamentation".

There is nothing accidental about Klimt's frequent choice of a square canvas, especially for his landscape paintings. This format, which he had first chosen for *Pallas Athene*, made it possible for the subject to have an appearance of repose, to be bathed in an atmosphere of peace, as Klimt put it, to become part of the totality of the universe which was so important to him. Malevich was pursuing similar aims with his *White Square on*

Portrait of Margaret Stonborough-Wittgenstein, 1905
This time it was not the spouse but the father of the bride who commissioned the portrait, as a wedding gift. Margaret was a leading light among the intellectual and cultural élite of Vienna, and she enjoyed making this decorative masterpiece the focal point of her white-walled house with its Cubist interior.

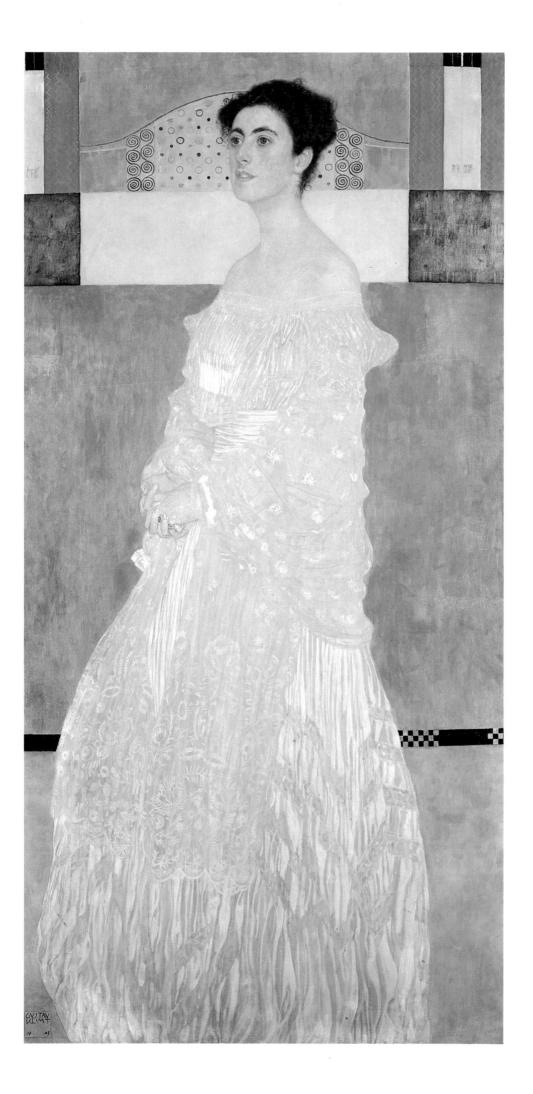

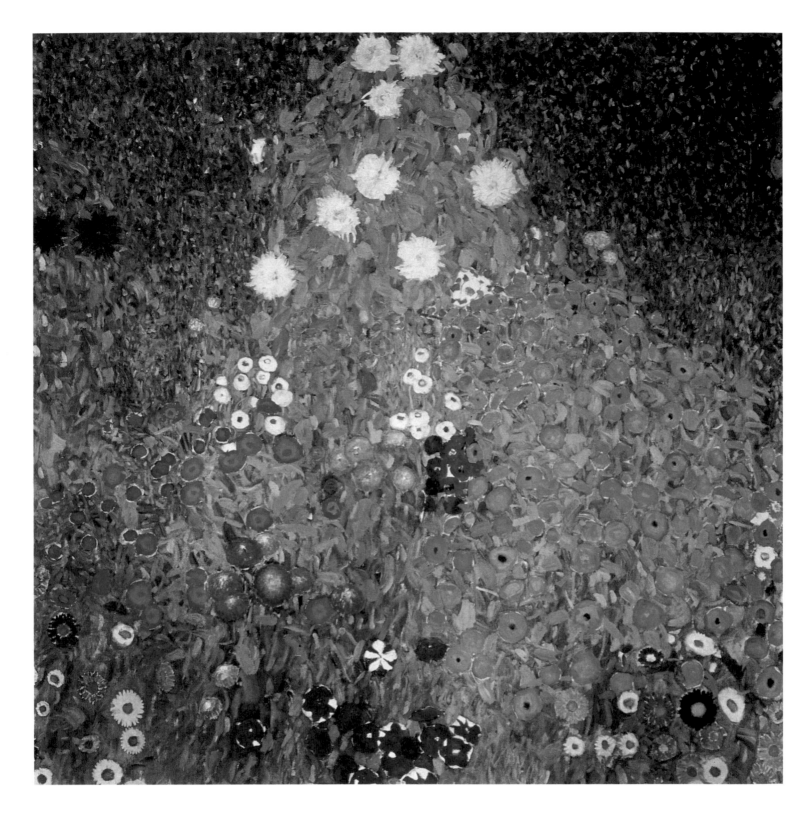

Farm Garden (Flower Garden), 1905/06
This garden in bloom is Klimt's garden – the partial representation
of a grand whole, of a greater entity endowed with mystical
power. His flowers fill every inch of space, like Monet's water
lilies.

Gustav Klimt was not gregarious; he was a man of few words,
who preferred solitude to society. His garden not only inspired his
flower paintings; it was the wellspring from which he drew
strength for all his work.

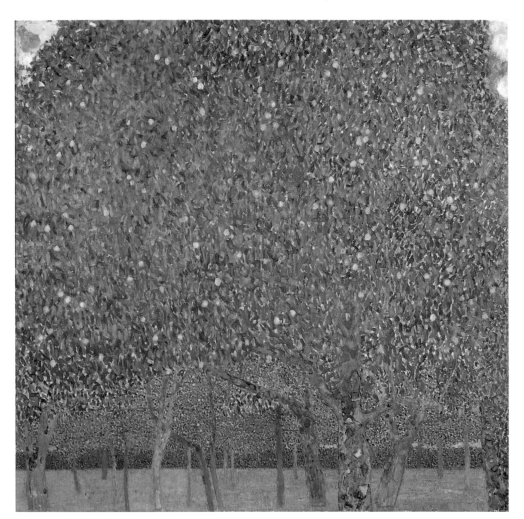

Pear Tree, 1903
Klimt favoured the square format for his landscape paintings, not by chance and not for convenience. As he himself said, "This format makes it possible to bathe the subject in an atmosphere of peace. Through the square the picture becomes part of a universal whole."

White Background, which for him was a cosmic symbol on a higher level than the Christian cross. For Klimt, as for Monet in his last active phase, the remarkable property of the square was that it could be developed in any direction without the need for central reference. Monet's water lilies take up the entire picture and could extend beyond it, and in a similar way Klimt's landscape motifs are sections of the universe. Unlike the French Impressionists, however, Klimt is not interested in meteorology and changing light: what interests him is the partial representation of a great mystic whole. This is evident from the first in the astonishing pictures of water which he began to paint in 1898 on Lake Attersee, where he was to spend his summer vacations at the invitation of the Flöge family.

It becomes even more apparent in his forest pictures. The method he uses in *Pear Tree* (see p. 52) is reminiscent of Neo-Impressionist pointillism, and it establishes a rhythm which could continue for ever; the manner in which trees, and leaves are painted creates a sense of matter extending to infinity. *Farm Garden with Sunflowers* (see p. 53) or *Farm Garden* (see p. 50) make one think in terms of an "imprint" of a section of landscape, of textile surfaces printed with luxuriant vegetation, quite different from van Gogh's interpretation of the sunflower opening like an eye and blazing like fire. Yet both artists want to capture the ineffable, to apprehend that which escapes us... For van Gogh, the sunflower symbolises a

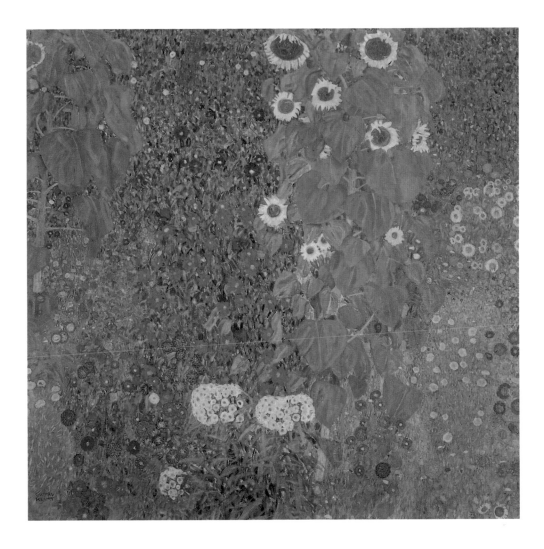

Farm Garden with Sunflowers, 1905/06
Unlike van Gogh, for whom sunflowers were of paramount importance, Klimt does not make of the flowers a flaming and consuming fire. His flowers shimmer like the gown of a "fairy in love". (Hevesi)

blinding sun, ultimately a cause of death or insanity. For Klimt, it has a mystical aura, dwelt on by Ludwig Hevesi: "Klimt planted a simple sunflower in the flowering medley, and it stands there like a fairy in love, its grey-green skirts flowing downwards in shimmering passion. The sunflower's face, so dark and mysterious within its gleaming gold circlet, has a mystical, indeed a cosmic, significance for the artist. Does not an eclipse of the sun look just like that?"[9]

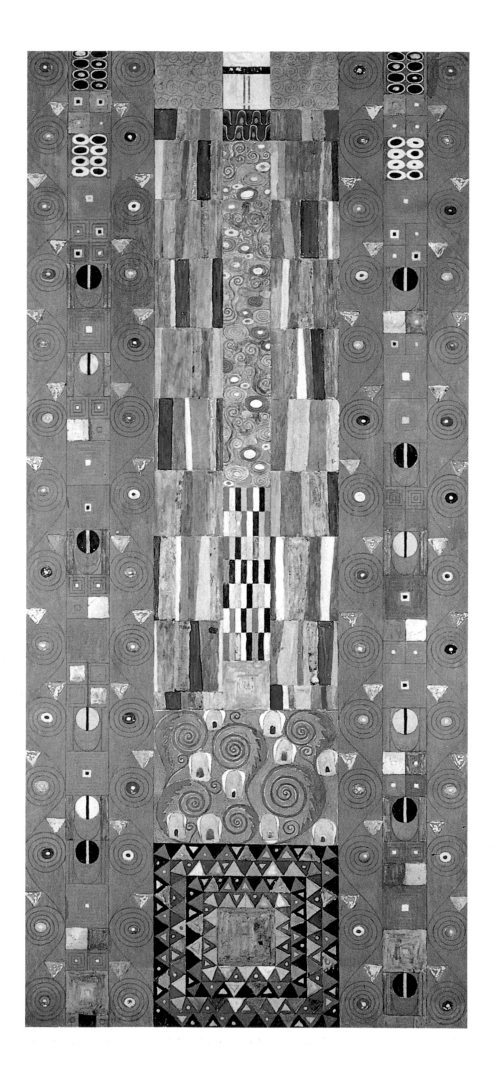

The Exotic Mosaics of the Villa Stoclet

In Klimt's last great mural work, the *Stoclet Frieze* (1905–1909), the life cycle is presented once again, but in a more serene way than in the Beethoven Frieze. While Adolphe Stoclet, the Belgian industrialist, was living with his wife Suzanne Stevens in Vienna, he gave the contract for a new house in Brussels to the Vienna Workshop, to Josef Hoffmann and Gustav Klimt. "The commission", explains Hoffmann, "was to use architecture and new motifs to replace old styles, and to find the right form and minimum proportions for maximum utility with the greatest precision possible."[10] The Secessionists' principles foresaw interaction between the arts, thus between architecture, painting and sculpture. "The painter will be called upon to decorate the interior. He will no longer be obliged to paint figuratively, but will be able to express his ideas directly in shapes and colours without recourse to narrative details."[11]

Le Corbusier and his co-worker Léger had similar ideas: "Let us take the picture out onto the street, comrades, so that all can profit from it." The devotees of Purism had the same aims as the Secessionists. The Purists saw in a bare wall a "dead surface", whereas a coloured wall became a "living surface". A coloured surface may "either serve as decorative accompaniment or destroy the wall" (Léger): the living-space which the "constructors' painter" describes as an "inhabitable square" can be transformed into an "elastic square", so that a yellow wall "vanishes" (is destroyed), while other walls, depending on the choice of colours, may either "move forward" or "retreat"... To conclude: "Colour is a powerful active force: it can destroy a wall, it can adorn it, it can make it move forward or back, it can create this new space... The attainment of perfect beauty in an equilibrium of new plastic forces... is what modern architecture must seek to achieve" (Léger).

Josef Hoffmann sees the ornamental potential in walls, rather than seeing walls merely as large surfaces. In his view – one shared by the Vienna Workshop – ornamentation must be conceived in symbiosis with architecture; hence his collaboration with Klimt. His *Palais Stoclet* (see p.55 top) is constructed of large "inhabitable cubes" with white marble revetment, its contours emphasised by angular strips of copper along the edges. Klimt, for his part, created an ornamental three-part mosaic frieze of marble inlaid with gold, enamel and semi-precious stones.

This collaboration between art and architecture is a watershed in art history. Comparable notions would become the creed of the Bauhaus and the

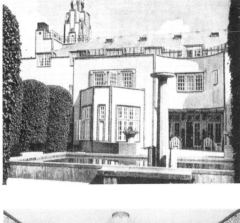

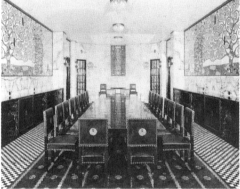

Josef Hoffmann: Palais Stoclet, Brussels. Exterior (above), and dining-room with G. Klimt's mosaics, 1905–11

The Stoclet Frieze, 1905–09
Deliberately drawing on architecture and interior design, Klimt's decorative panels play with geometrical abstractions.

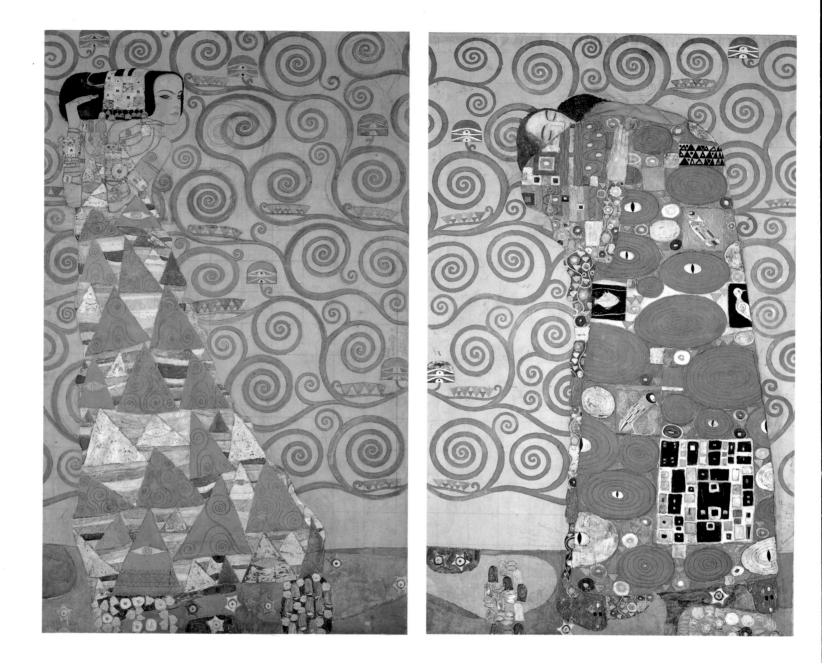

Expectation, working design for **Stoclet Frieze**, c. 1905–09
The girl dancing beneath one of the trees of knowledge represents Expectation, an attitude characteristic of Klimt's women during the period following his *femmes fatales*. The oriental influence can be traced to the Stoclets; they were collectors of oriental art and Klimt wanted to create a fitting décor for his patrons.

Fulfilment, working design for **Stoclet Frieze**, c. 1905–09
These figures, giving a foretaste of **The Kiss**, are worked in part in mosaic, a technique which Klimt had encountered in his youth and rediscovered when he travelled to Ravenna.

Russian Constructivists in the 1920s. The latter, however, like Le Corbusier and Léger, wanted their work to be accessible to all mankind, whereas Hoffmann and Klimt were only able to realise their ideals in the service of a wealthy patron, thereby serving, in a sense, the taste of an élite.

The nine panels of Klimt's frieze contain abstract motifs (see the decorative panel reproduced on p.54), stylized ones (*Tree of Life*, see p.58) and figured ones (*Fulfilment*, see p.56; *Expectation*, see p.56). In this work more than in any other, Klimt displays his mastery of mosaic. He had learnt the technique at the School of Applied Art, and rediscovered it later when he travelled to Ravenna. It was the Wiener Werkstätten above all that attached particular importance to the technique at the time, giving it a new lease of life.

The Stoclets were great collectors, interested first and foremost in Indian and Buddhist art, of which they possessed many pieces. Klimt wanted to take their passion for the Orient into account and began to create the right setting for his patrons and their treasures, so he studied Oriental art without delay. His designs included some elements reminiscent of the exotic world of the Far East, and some reminiscent of the Byzantine

mosaics of Ravenna, the Byzantine spirals acquiring an exotic luxuriance, a biological and ornamental eloquence.

The tree of life is the central motif of the frieze. According to the Apocalypse, the tree brings redemption to the heathen; it is a symbol of the Golden Age, used by Matisse it a little later in his famous chapel at Vence. For Klimt, it is a symbol in which all the motifs important to him are united, from flower to woman, from the death of vegetation to the rebirth of the seasons. Trees and women intermingle in paradise, in a magical world in which people dance and love one another, in which women become trees – like Matisse's women metamorphosed into plane trees – grow and spread through the whole of nature. With the tree of life and the tree of knowledge, one is indeed in the Garden of Eden. The girl dancing under one of the trees represents *Expectation* (see p. 56). The couple embracing beneath the other tree represents *Fulfilment* (see p. 56). And, of course, death too is present, as might be expected in Klimt's or Freud's version of the normal life-cycle, to be observed in the form of the birds of prey sitting in the tree of life (see p. 58). The embracing lovers, still antagonists in the *Beethoven Frieze*, have been replaced in the *Stoclet Frieze* by a tranquil symbol of domestic happiness, fulfilment and joie de vivre.

A further development of the same motif is found a little later in Klimt's famous *Kiss* (see p. 63), which represents the culmination of his "golden period"; it became the emblem of the Secession. This version is an even clearer symbol of the reconciliation and union of the sexes. Klimt's *Kiss* has been compared, with a certain irony, to the *Mona Lisa*, both pictures owing some of their fascination to a complexity of meaning. Some observers see a new development in Klimt's ability as seen in this work to paint the union of the sexes, whereas up to this point he had painted above all the battle between them. Others, in contrast, see no change in Klimt's attitude, regarding this picture as describing in a more subtle way precisely that impossibility of fulfilment arising from the tensions between man and woman. Do the contrasting elements of ornamentation – based on squares for the man and circles for the woman – complement each another, or is there antagonism between them? Do these two people not keep at a certain distance from each another, in spite of their embrace, as if there were in fact no relationship between them? It is at least clear that it is the man who dominates and takes the initiative in the act of the kiss. The woman offers no resistance, yet her hands are tense and her toes grip the rock – in voluptuous pleasure or in anger? Klimt knows the ambivalence of the relationship between the perennial figures of Adam and Eve: he was himself the model for his Adam, and he holds his beloved, Emilie Flöge, in his arms.

However close or distant the embrace, the sexual impact of the portrayal is defused by the garments that clothe the figures. The strikingly virtuoso juxtaposition of colours is reminiscent of Eastern Mediterranean illuminated manuscripts. Loving luxuriant décor as he does, Klimt looks at this intimate scene as if through a kaleidoscope. The profusion of gold and lavish materials gives the picture a breathtaking aura that made it possible for the *Kiss* not only to escape censorship, but even to be greeted with public enthusiasm and to win the acclaim of the puritanical bour-

The Royal Scribe Ptahmose, 19th Dynasty

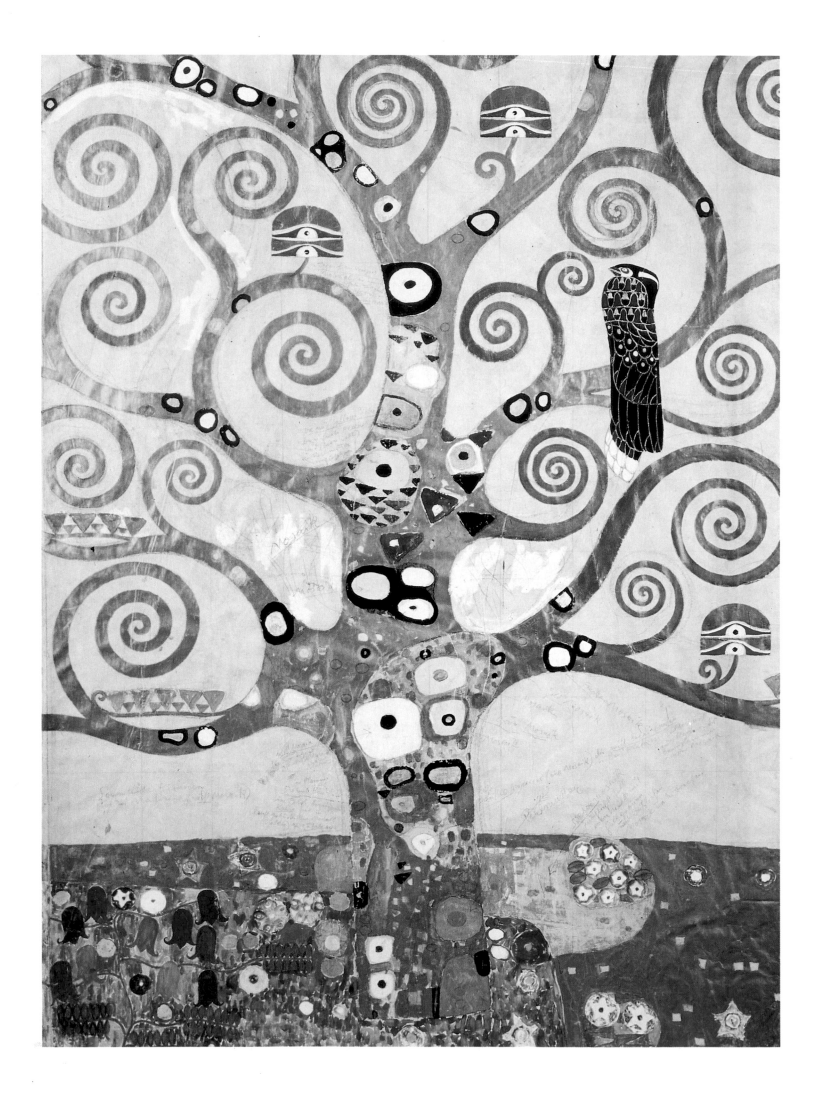

geoisie. This time Klimt's "coup" was so successful that his contribution to modern European art was finally recognised. The painting was purchased for the Austrian nation even before the Kunstschau of 1908, where *The Kiss* had been exhibited, was over.

Klimt's masterpiece notwithstanding, this exhibition was the swan song of Vienna aestheticism. Strangely enough, Klimt's rehabilitation took place at the very moment of the Secession's demise. He was even asked to give the address at the opening of this great exhibition in honour of the Emperor Franz Josef's diamond jubilee. He took the opportunity to affirm his fundamental conviction, unchanged by the evolution of his work, that "no area of human life is so insignificant or trivial that it cannot offer scope for artistic endeavour… the humblest thing, executed to perfection, serves to increase the beauty of this earth, and progress in culture can be grounded only in the ever more progressive permeation of the whole of life with artistic purpose."[12]

Two further pictures by Klimt were exhibited in the Kunstschau, the allegories *Hope II* (see p. 45 right) and *Danae* (see p. 64), and in these pictures Klimt's message again was milder than before. Just as the multicoloured ornamental motifs adorning his nudes made them more acceptable, so also the symbolic motifs in the second version of *Hope* alleviated the shockingly aggressive nudity of the earlier version (see p. 44). Like the *Kiss* and the *Three Ages of Woman*, *Hope II* is conceived of as an icon, in which the vitality of colour permits a less bitter interpretation of the theme. However, it is not safe to take Klimt's milder tone as an indication that he had changed his philosophy – he was simply showing a less confrontational side of himself.

Is there any more beautiful portrayal of the ecstasy of love than his *Danae* (see p. 64)? After Zeus had "visited" Danae in the form of a shower of gold, she bore a son, Perseus. For this portrayal Klimt chose the by no means immaculate moment of conception. A stream of gold pieces mingled with golden spermatazoa pours down between the magnificent thighs of the sleeping beauty. In a certain sense this is a case of rape, since one may assume that the passive heroine knows nothing of what is happening. Moreover, the unconscious erotic experience of the sleeping Danae makes us, as witnesses of the scene, at once voyeurs and accomplices – just like the Viennese public at the time. From this mystery of female sexuality there emanates a powerful and direct eroticism, which is magnified by the close-up enlargement of the voluptuous body. The model herself resembles Klimt's preferred red-head *femmes fatales*, transformed at times into pin-up girls, whom we have seen emerging as naiads, as nymphs, even as the hostile powers in the Beethoven Frieze. But more than ever we see woman as the bearer of life's mystery, and the central focus of interest for Klimt the man and Klimt the painter. His insatiable curiosity compels him constantly to portray woman from every angle in every situation, even as lesbian in *Water Serpents* (see p. 46 right and p. 47).

The myth of Danae is simply a pretext, allowing Klimt to represent woman's ecstasy of love, as he himself had perhaps experienced it. At this time he also painted a *Judith II* (see p. 29) – or Salome, if one so wills – at a safe distance from the legend that had brought him such

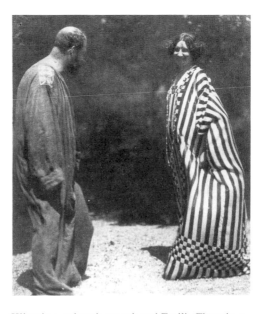

Klimt in a painter's smock and Emilie Flöge in a dress designed by Klimt for her fashion house. It displays the patterns that the Secessionists liked so much – chess-board and stripes in black and white.

Tree of Life, working design for *Stoclet Frieze*, c. 1905–09
This is the tree of knowledge spoken of in the Book of Revelation, symbol of the Golden age, calling into question the black bird, symbol of death – the normal life cycle as understood by Klimt and by Freud.

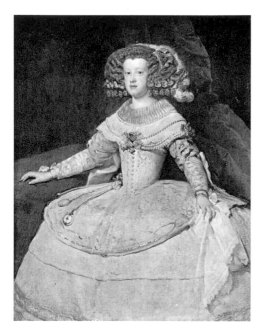

Diego Velasquez: *The Infanta Maria Teresa*, c. 1652

Portrait of Fritza Riedler, 1906
However respectable his subject may appear, Klimt's décor is far from ingenuous, even when it is disguised, as here, in the form of a fan-shaped headdress modelled on Velasquez. The eroticism of the artist's view of life finds expression in a latent sexual symbolism which cumulatively leaves its mark on the unconscious of the beholder, making him, in the truest sense of the word, a voyeur.

trouble with *Judith I* (see p. 28 right). Yet the question still remains whether this is a Judith who has used her powers of seduction to lure Holofernes into a deadly trap, or a Salome who demands the head of the Baptist because he has refused to succumb to her charms. The undulation of body and dress is suggestive of the dance; at the same time, what we see here is a lady from the decadent society of Vienna who has fallen prey to passion. She looks like a brightly feathered bird about to tear apart and devour her favourite prey – man – yet caught in her golden cage, from which there is no escape.

One has the same impression of a bird in a golden cage when one looks at the paintings of *Adele Bloch-Bauer I* (see p. 62) and *Fritza Riedler* (see p. 61). Do not these two great ladies of Viennese society look as if they are fearful, or at least frustrated, prisoners of their social stratum and their wealth? They bear a strong resemblance to the portraits of women by Velasquez which Klimt had seen in Vienna. Those women too seem to be oppressed by a weighty heritage, the sad reality of life and the decline of Spain, comparable in some ways to the decline of the Austrian Empire in Klimt's day. Like Velasquez, however, Klimt is able to create the illusion of life to the full. In another way, he resembles Ingres or Matisse, namely in his ability to set before us in these portraits "the secret object of desire". Eroticism is brought into the open, fantasies break the bounds of convention. Dress becomes one with the body, fabric merges with flesh. Shoulders and arms reflect fantasy actualised in ornamentation, the fall of a gown echoes a crease in the skin. The gown itself was perhaps painted onto the naked body and could disappear in a trice, ceding to triumphant nudity... All these portraits tend towards the highest level of graphic expression and towards sensuality, all the more refined in that the women are seemingly or truly unaware of the erotic desire they arouse. Temptresses they may be, but unconsciously so. They seem gentle, submissive creatures, who think as little as possible and like to stretch out on a sofa. What could be more alluring? The same atmosphere prevails in Ingres' *Madame Moitessier* (1856) and in Matisse's *La Dame en bleu* (1937) as in Klimt's *Portrait of Adele Bloch-Bauer I* (1907). But Klimt's eroticism is perverse. Though his models may have something of the priestess in them, décor and clothing do not share this quality. What is the significance of all those watching eyes in the décor of Fritza Riedler's chair and Adele Bloch-Bauer's dress, or of the ambivalent variations on fantasy ornaments and expanses of colour, or of the decorative motifs laden with turbulent and compulsive erotic symbols, or of the contrast between the realistic, fine draughtsmanship of the immobile faces and hands and the eroticism of decorative frenzy? Ludwig Hevesi, art critic and passionate champion of Klimt's work, says: "Klimt's ornamentation is the figurative expression of primal matter, which is always, without end, in a state of flux, turning and twisting in spirals, entangling itself, a whirlpool that takes on every shape, zebra stripes flashing like lightning, tongues of flame darting forwards, vine tendrils, smoothly linked chains, flowing veils, tender nets."[13]

The ornamentation in Klimt's work grew more and more sumptuous. There may be an extraneous reason for this superabundance. His friend and companion, Emilie Flöge, ran a fashion house in Vienna, and he

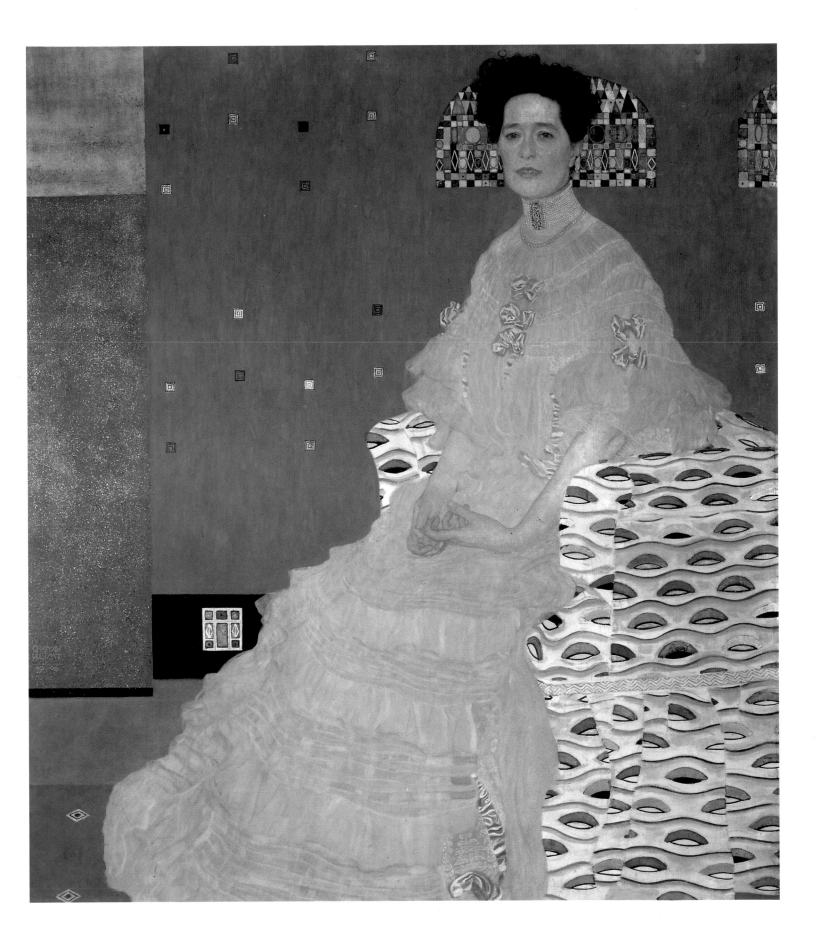

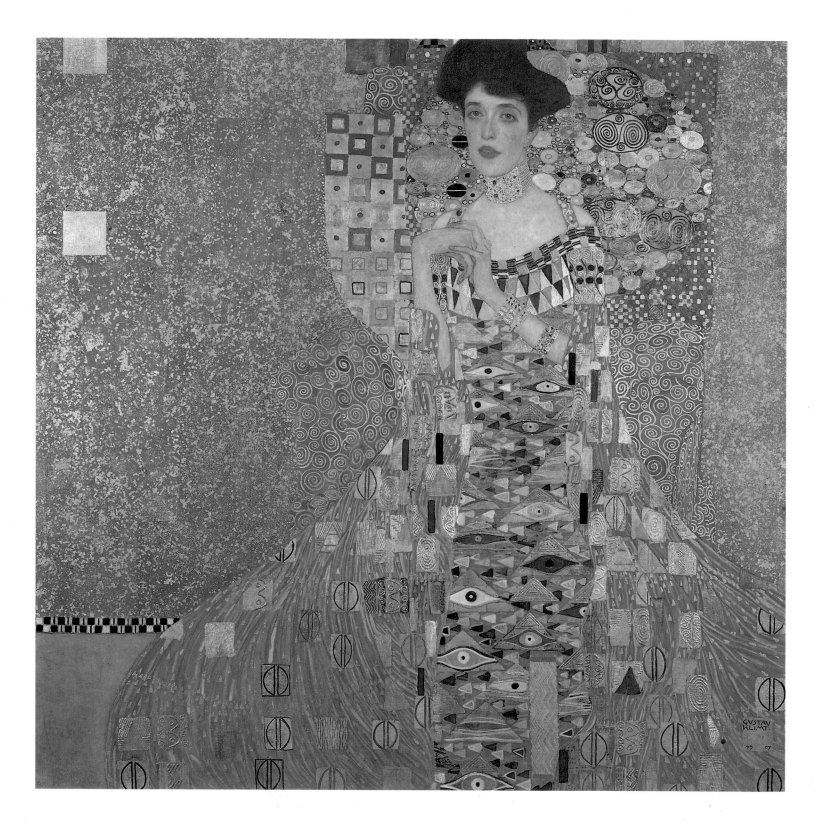

Portrait of Adele Bloch-Bauer I, 1907
Realism and abstraction undergo a synthesis in this portrait, as in the
Stoclet Frieze. Klimt covers the surface in the Byzantine manner al-
ready noted in his landscape paintings. Exotic symbols, such as the
Egyptian eyes set in triangles or the Mycenaean spiral scrolls so
favoured by the artist, escape attention at first glance.

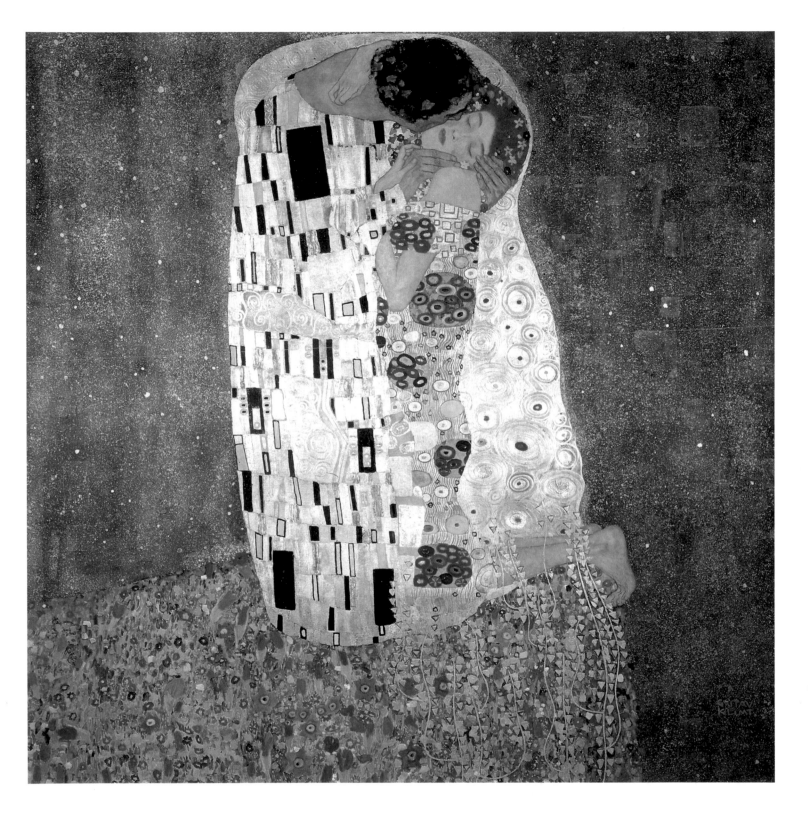

The Kiss, 1907/08
New ground is broken here: Klimt's otherwise dominating woman
becomes submissive. She yields to the man, abandons herself to him,
and sexuality shimmers through her clinging gown, which is none-
theless sufficient to escape the censorship that deems carnal embraces
taboo. Klimt, who was in effect holding up to the puritanical Viennese
bourgeoisie a mirror of their hypocrisy, was rewarded by their enthusi-
asm. Models for the painting: Klimt himself, holding his beloved
Emilie Flöge in his arms.

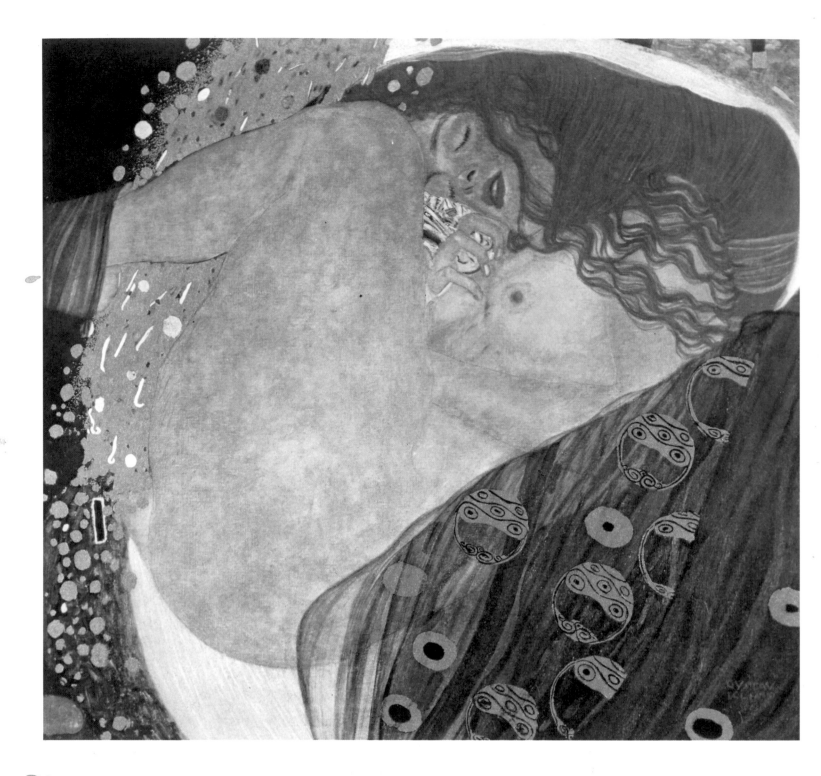

Danae, 1907/08
After the **Kiss** Klimt became less willing to conceal: this is the ecstasy of love, at the very moment when the shower of gold pieces mingled with gilded spermatozoa – the form in which Zeus chooses to "visit" the sleeping heroine, symbol of carnal and sensual beauty – pours down between her gigantic thighs.

designed most of the materials she used; these designs contributed in no small measure to the success she achieved with her models among the wealthy ladies of Vienna. In the photograph that shows her with Klimt (see p. 59), she is wearing a garment designed by him, with the chequered pattern and black-and-white stripes so popular with the Secessionists. Such decorative attributes are used to enhance the monumental dignity of the industrialists' or magnates' wives depicted in the portraits, often sitting like goddesses on their thrones. The magnificent "imperial" gold heightens the majestic appearance of these ladies. A contemporary critic writes in connexion with the portrait of Adele Bloch-Bauer of an "idol in a golden shrine", an expression that calls to mind the portrayal of the Empress Theodora which Klimt had seen among the mosaics in San Vitale.

The recurring element of gold has various meanings in Klimt's œuvre. In the early works, it underlines the sacral, magical quality of certain objects, such as the cithara of the priestess of Apollo in *Music II* or the helmet and weapons in *Pallas Athene*. If, later, he clothed his *femmes fatales* in gold – as in *Judith*, in *Goldfish* or in *Jurisprudence* – this strengthened their suggestive power. But even during his "golden phase", Klimt would only let gold dominate in pictures which treat of man's destiny. These work belong to a distinctive genre, that of "life's enigmas".

Klimt's "golden phase", which might well also be regarded as his "golden age", begins with the *Portrait of Fritza Riedler* of 1906 (see p. 61), and culminates in the *Portrait of Adele Bloch-Bauer I* of 1907 (see p. 62). Klimt doubtless realised the danger of superabundant ornamentation for him as a painter on beholding the scale of his use of gold and gilding in the decoration of this picture, both in the luxuriant background and in the lady's exquisite dress. Nevertheless, these gilt-edged ladies are among the most significant pictures within his œuvre of turn-of-the-century women, torn between the conservative tradition to which they were obliged to conform and an incipient awareness of emancipation.

At the very moment of personal triumph, Klimt began to have doubts. The Secession, the ideal of harmony among artists, had turned out to be a utopian notion. The concept seemed to him to have grown old, however often it might be revived. Klimt found himself isolated, no longer a leader whom others followed. He confided to Bertha Zuckerkandl: "The young no longer understand me. They go elsewhere. I don't even know whether they appreciate my work any more. It's a bit early for that to happen to me, but it happens to every artist. The young will always want to take everything that's already there by storm, and pull it down. I shan't get angry with them over it."[14]

The reality was that for these young artists – Egon Schiele and Oskar Kokoschka – he was nothing less than a god. But what is known as the "truth" of a work of art is subject to change. The extravagantly ornamented world of Klimt's pictures is positively optimistic and conciliatory, compared with the ruptured world of Schiele, which is closer to the "laboratory of the apocalypse", as pre–1914 Vienna was termed. Schiele and Kokoschka, the Pre-Expressionists, shared not only their veneration of Klimt but also a stronger premonition than he felt of the final destruction and catastrophe that was to come. It was now their turn to exert an influence on their idol. If Klimt's influence on Schiele had been decisive in the years around 1910, the influence was now reversed, as was the case with Manet in his old age and the young Monet. This becomes apparent in one of Klimt's late pictures, *Leda* (see p. 65 below), clearly based on an earlier composition by Schiele. This example shows the convergence and the creative rivalry between these painters, who were of paramount importance in Viennese art at the time.

Egon Schiele: Study for **Danae**, 1909

Crouching semi–nude, viewed from the right, study for **Leda**, 1913/14

Leda (destroyed), 1917
Having been influenced himself by Klimt, Schiele in turn influenced his "god". An example of the creative exchange linking the two greatest painters in Vienna at the time.

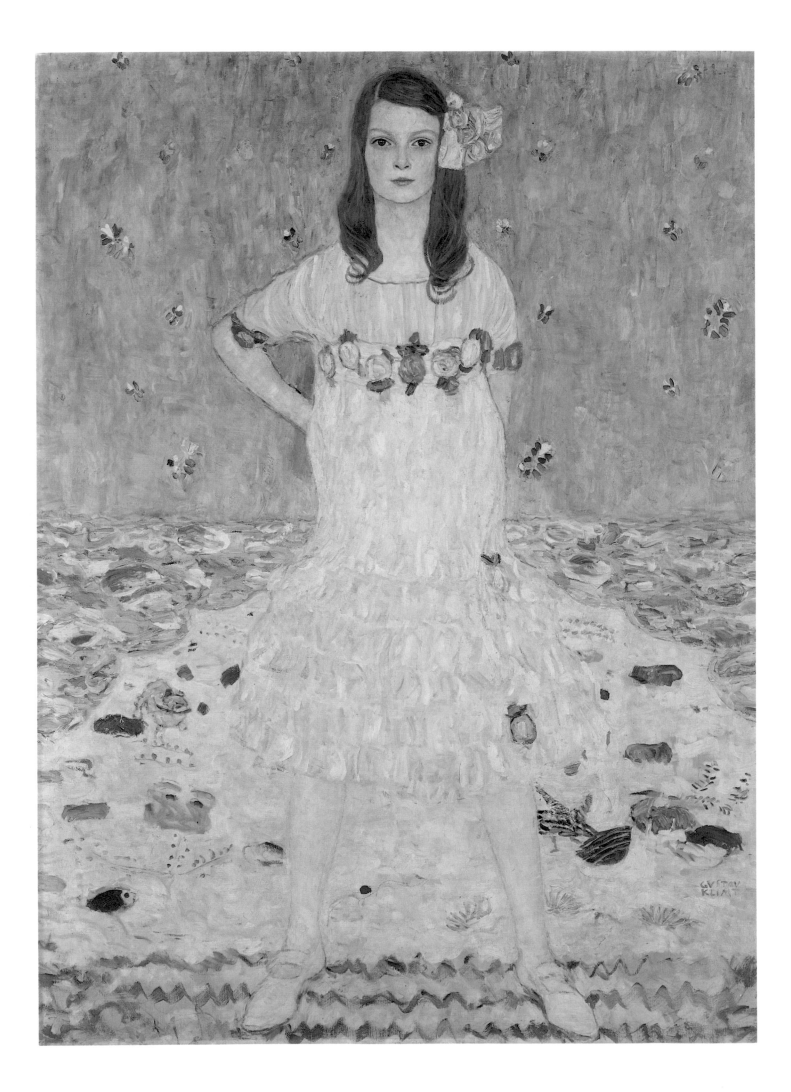

The Magic Kaleidoscope

The beginning of Expressionism coincided with the end of Klimt's "golden phase"; he had come to recognise that gold led to rigid stylisation, rendering all subtlety of psychological expression impossible. The range of expression displayed by the likes of Edvard Munch, Pierre Bonnard and Henri Matisse at the Exhibition of 1909 was overwhelming. This, he felt, was the direction that his future work must take. Before the year was out he travelled to Paris, where he discovered the works of Henri de Toulouse-Lautrec and the Fauves. These encounters spurred him on and ultimately made possible the magic synthesis of the kaleidoscopic works of his late period – once more, Klimt had proved himself capable of change.

The golden or Byzantine style and splendid décor had often made the person seem insignificant in contrast. Klimt resolved to lighten the ornamentation and décor and to find new ways forward by returning to the rich store of attractive motifs that he had at his disposal. Pictures like *Lady with Hat and Feather Boa* (see p. 68) and *Black Feather Hat* (see p. 69) are the first to show a radical change of direction – one, however, which was soon to give way to something else.

Familiar with the latest fashions in haute couture through his association with Emilie Flöge's salon, Klimt made use of fashionable coiffures, make-up and accessories in order to transform his *femmes fatales* into less threatening creatures; they display their extravagant hats and enormous if playful muffs with simulated modesty.

The great works of Klimt's last phase are revealed in portraits like that of *Mäda Primavesi* (see p. 66), a girl in whom we see the new feminine principle in Klimt's art, namely the blending of woman and floral ornament. "The anatomy of the models becomes ornamentation, and ornamentation becomes anatomy"[15] (Alessandra Comini). The culmination of this new style is to be found in *The Dancer* (see p. 72).

For further means of lessening the density of decoration, Klimt turned to the woodcuts and books on Japanese art in his collection. Like Monet or van Gogh, indeed like all artists and intellectuals of the time, Klimt was fascinated by Japanese woodcuts, which he had encountered in 1873 at the World Exhibition in Vienna. He collected woodcuts and other Nipponese objects, and his draughtsmanship owed a great deal to them, especially in the composition of the kaleidoscopic paintings, drawn as it were from a bird's-eye view. He had used Japanese models for the tree of life

Composition sketch depicting Mäda Primavesi, 1913

Portrait of Mäda Primavesi, c. 1912
Klimt's newfound feminine principle: woman and flowers intimately linked.

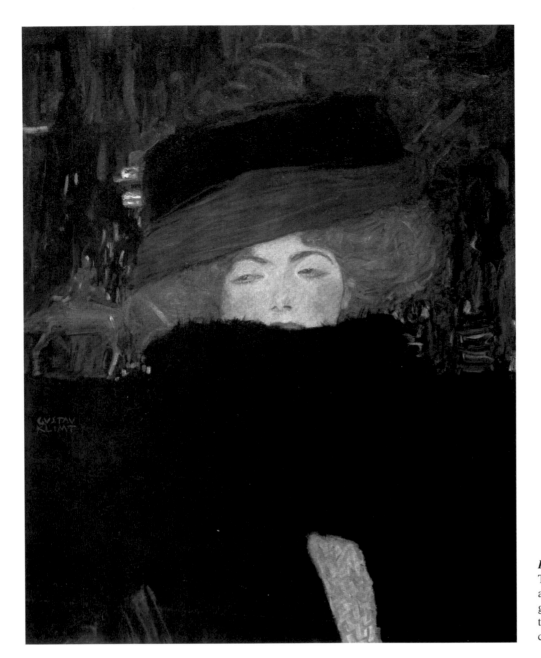

Lady with Hat and Feather Boa, 1909
The emerging Expressionist art of Egon Schiele and Oskar Kokoschka saw the end of Klimt's gold style. For a time he abandoned the ornamentation of his paintings in favour of large monochrome areas.

in *Fulfilment*, and for the flowers and birds in the *Stoclet Frieze*. Their influence also seems to have encouraged him to fill to profusion the background of his portraits with oriental decorative motifs, as in *The Dancer* (see p. 72), the *Portrait of Baroness Elisabeth Bachofen-Echt* (see p. 80 right), or the *Portrait of Friederike Maria Beer* (see p. 81 left). One cannot help comparing these portraits of women with earlier paintings by Monet or van Gogh. Monet's *La Japonaise* of 1876 (see p. 81 below right), a portrait of his wife, Camille, with kimono and fan, is complete with Japanese-style décor, walls and floor strewn with fans of different colours. Van Gogh's *Le Père Tanguy* of 1887 (see p. 81 above right) shows the art-dealer amidst Hiroshige woodcuts which fill the entire background of the picture.

Klimt's new-style works met with undiluted public acclaim. The underlay of floral motifs in his portraits appealed directly to the unconscious, and he became fashionable once more. The nouveaux riches vied with one another to obtain a portrait of one of their womenfolk signed by

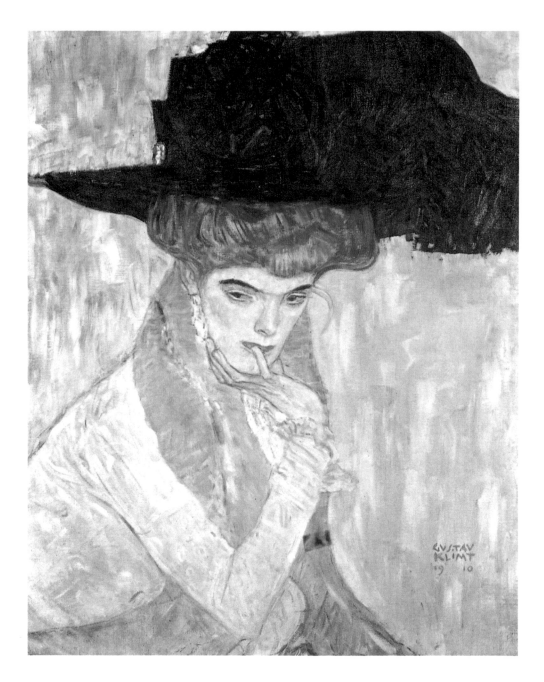

Klimt, while Vienna's beautiful ladies dreamt of being granted immortality by the master's hand...

The themes of these portraits are still Eros and the life cycle, but without their unpleasant aspects. Woman may still be a sex symbol, but apparently a much more innocent and more straightforwardly charming one than the *femme fatale* or the vamp. Whether it be *Adele Bloch-Bauer II* (see p. 77), *Eugenia Primavesi* (see p. 78 right), *Baroness Elisabeth Bachofen-Echt* (see p. 80 right), or *Friederike Maria Beer* (see p. 81 left), all these women, these modern idols, have something in common: they seem to be waiting, rather like large dolls, for someone to take them out of their boxes and play with them... Is not this mood of waiting or anticipation, discernible ever since the *Girl from Tanagra* (see p. 8), just one variation of the inescapable theme that runs right through Klimt's work, namely Eros and the cycle of life? One version of it was perceptible in the expectant nude of *Hope I* (see p. 44 right), and its continuation persists in the new portraits of women who are waiting for something... The

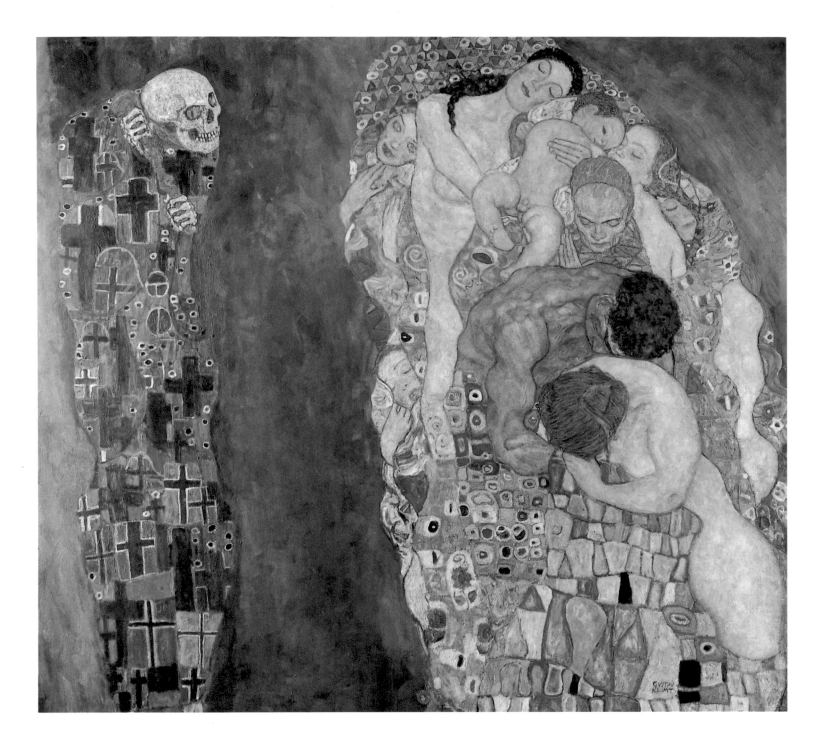

Death and Life, 1916
This is one of Klimt's central themes, central also to his time and to his contemporaries, among them Edvard Munch and Egon Schiele. Klimt makes of it a modern dance of death, but, unlike Schiele, he introduces a note of hope and reconciliation: instead of feeling threatened by the figure of death, his human beings seem to disregard it.

imagination of the artist is focused no longer on physical union, but rather on the expectation that precedes it.

Perhaps this new-found serenity is rooted in Klimt's own awareness of aging and closeness to death. But before the moment came when he chose to depict nothing more than moments of intense pleasure or miraculous beauty and youth, he took up the theme of *Death and Life* (see p. 70), on which Munch and Schiele were also working, one last time. Joseph Roth describes this atmosphere in "The Capuchin Crypt": "It may be that in the hidden depths of our souls those certainties that men call premonitions were sleeping, above all the certainty that the old Emperor was dying with every day that he continued to live, and with him the monarchy, not so much our fatherland as our empire, something greater,

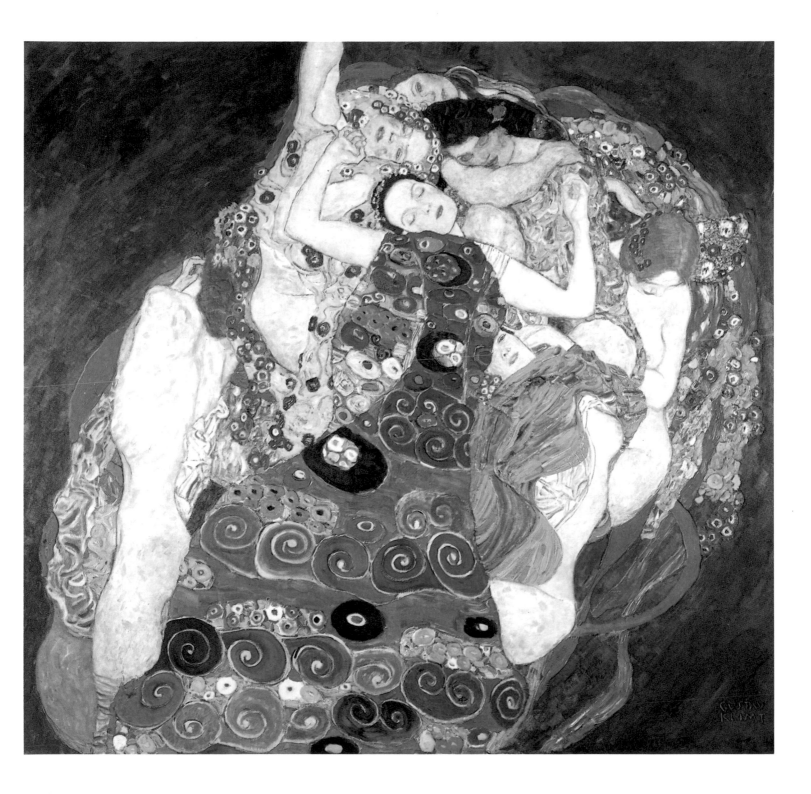

more extensive, more exalted than a fatherland. Out of our heavy hearts there came light-hearted jokes; out of our feeling that we were condemned to death there came foolish pleasure in every affirmation of life, in attending balls, in drinking new wine, in girls, in food, in excursions, in follies of every kind, in senseless escapades, in suicidal irony…"[16]

The young girl, whether in *Death and Life* or in *The Virgin* (see p. 71), seems to express the words of Sissy, Elisabeth of Austria: "The thought of death is purifying; it has the same effect as a gardener has, pulling the weeds out of his garden. But this garden always wants to be alone, and it becomes angry when curious people look over its walls. In the same way, I hide my face behind my parasol and my fan so that the thought of death can take effect in me peacefully."

The Virgin, 1913
Once again, Klimt joins together several figures: entwined, they hover on a bed of flowers like a cloud. The different figures represent different stages of sensual awakening; the girl becomes a woman.

PAGE 72:
The Dancer, c. 1916–18
Anatomy and ornamentation become interchangeable in the late portraits, and in celebration of this magical kaleidoscope Klimt's hand becomes lighter and lighter.

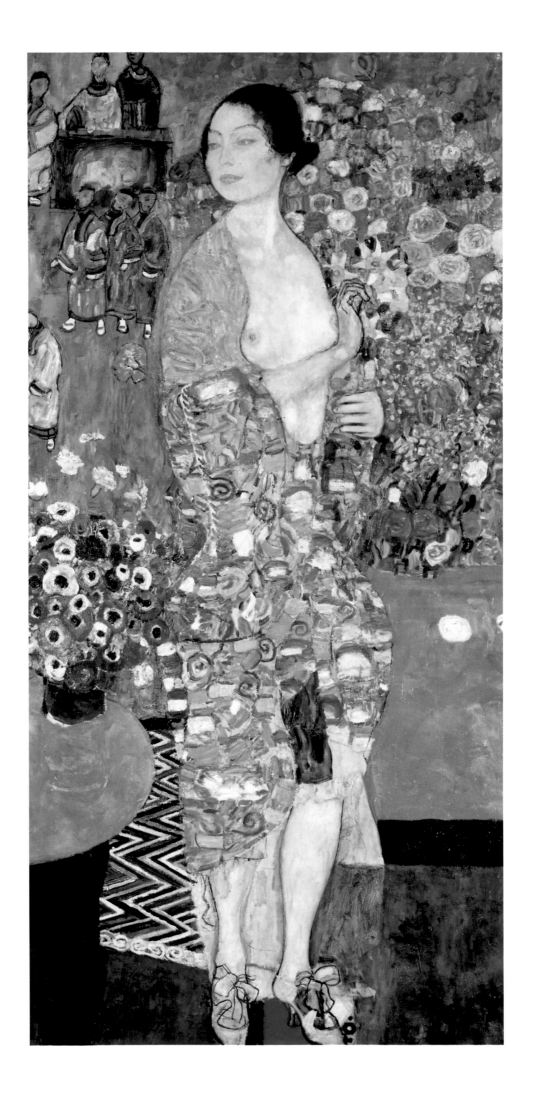

Sunflower, 1906/07

Apple Tree I, c. 1912
Unlike the portraits or the allegorical composi-
tions, the landscape paintings – which sold very
well – were painted for contemplative pleasure,
relaxation and meditation.

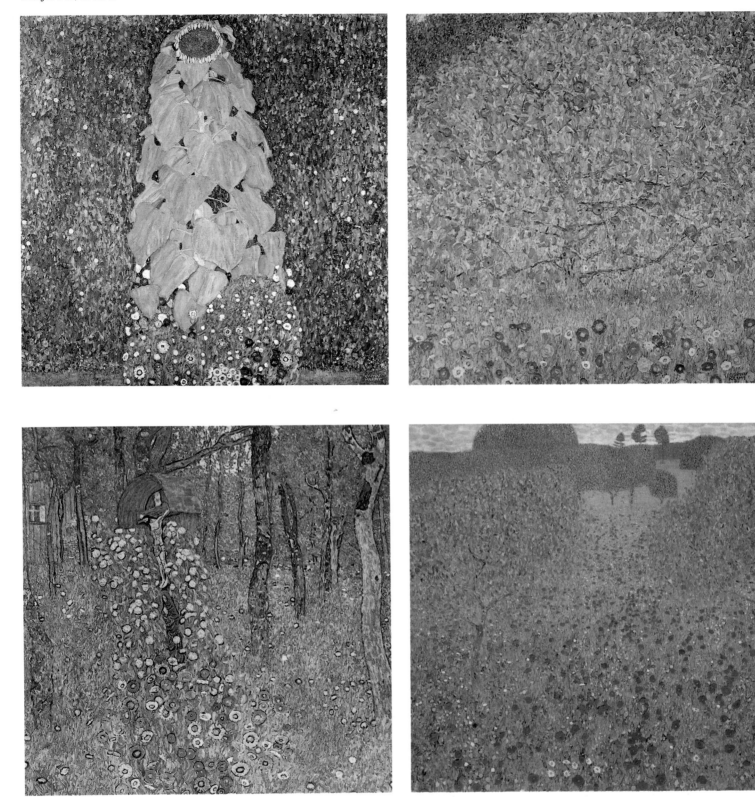

Farm Garden with Crucifix, 1911/12

Poppy Field, 1907
Klimt liked to paint his landscapes while on holi-
day, without preliminary studies, rather in the
way that Renoir liked to paint flowers with the
paints left over from his life studies as a means
of relaxation. Klimt's landscapes are in a sense
his holiday tasks.

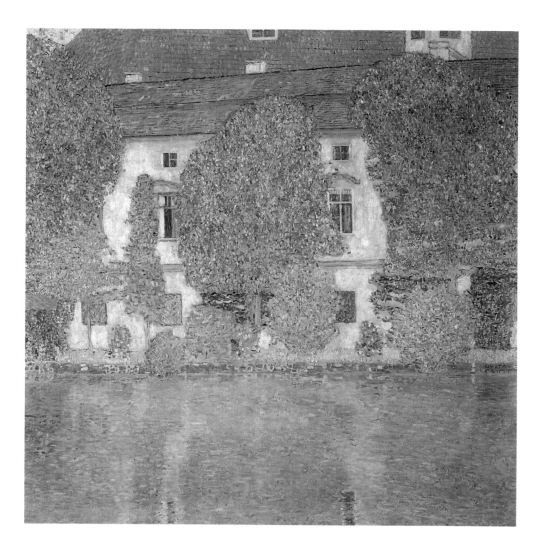

Schloss Kammer on the Attersee III, 1910
Klimt's landscapes gradually evolved from the tapestry or mosaic style to compositions which reflected emergent Cubism. The localities become more urban, incorporating architecture and linking water, vegetation and buildings. Only people are excluded.

Forester's House, Weissenbach on Lake Attersee, 1912

In painting his last pyramid-shaped allegories, such as *The Virgin* (see p.71) or *The Bride* (see p.91), Klimt used pure colours only; the kaleidoscopic composition seems to turn on a labyrinthine pivot. There is always a narrative to be told: the young girl becomes a woman; we experience the awakening of her senses, which will lead to the ecstasy of love. The different stages are represented by the same being, multiplied as if in a dream. Dislocated parts of female bodies, in diverse poses and moods, move as if they had been caught by a crazed camera. The pyramid of brightly coloured clothes, the empty shell of a woman's dress beneath it, seems to give birth to the "child" as from a joyful cascading waterfall. *The Bride* (see p.91) belongs to a still later phase, influenced by Schiele, which was terminated by Klimt's death... The flow of decorative motifs is no less powerful, but more importance is attached to the geometrical organisation of the canvas. The mêlée of figures seems kept in check by abstract elements. It becomes increasingly difficult to analyse these late works; the fact that they were left unfinished makes it impossible to divine their ultimate goal.

While the portraits of women were developing in this manner, a parallel development was taking place in the other branch of Klimt's work, namely his landscapes: the "tapestry" or "mosaic" style was evolving into a style of composition which shows incipient traces of Cubism. Instead of anonymous extracts from nature as a whole, we begin to see landscapes with urban elements, with architecture, with water, vegetation

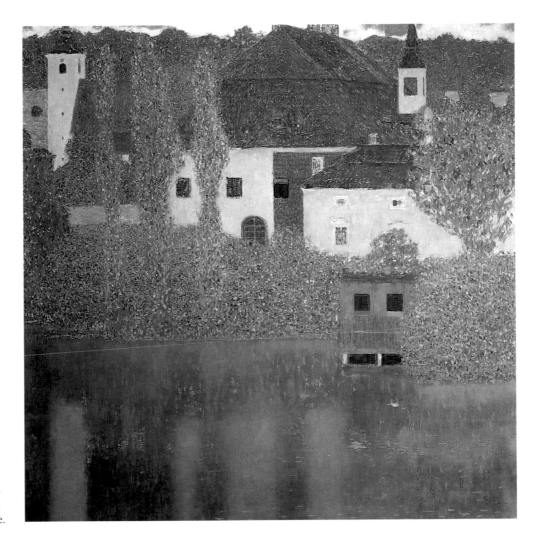

Schloss Kammer on the Attersee I, c. 1908
In the paintings of Schloss Kammer, Klimt studied the problem of incorporating architectonic elements in a landscape, that is to say mankind's impingement on natural surroundings and the resulting effects. Like Monet, Klimt used a rowing boat and set up his easel in the middle of the lake.

and buildings. As hitherto, mystic pantheism prevails, and human beings remain out of sight.

Commentators have registered surprise at the fact that Klimt – the studio painter who drew any number of studies before executing a portrait or an allegorical picture – apparently painted his landscapes out of doors, on the spot, without any preliminary drawing. It seems that he may have seen an opportunity in landscape painting for meditation and tranquillity, in rather the same way as Renoir found relaxation in painting flowers with what remained of the paints he had used for his life studies. Klimt regularly spent the summer months by the Attersee, enjoying the summer environment favoured by the Flöge family. He is not known to have painted any winter landscapes. The environs of the Attersee became something like a "holiday task", and his 230 canvases include 54 landscapes. Of his several thousand preliminary sketches, only three are for landscapes.

Schloss Kammer on the Attersee I or *III*, also known as *Castle on the Water* (see p. 75; p. 74 right), had a particular fascination for him; it enabled him to study the problem of integrating an architectural element into the landscape, that is to say of integrating a man-made element into nature. The third element is water. In order to paint in peace, without interruption, he used a rowing boat, as did Monet, setting up his easel in the middle of the lake. *The Church in Cassone* (see p. 76 left) represents a further development, the architectural element tending strongly towards

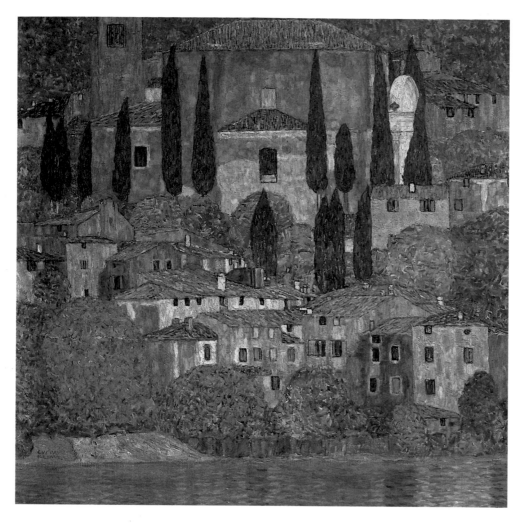

PAGE 77:
Portrait of Adele Bloch-Bauer II, 1912
After the phases of *femme fatale*, vamp and star, Klimt's gorgeous creations, these modern idols, became more like large dolls, lying in their shimmering boxes and waiting for someone to take them out…

The Church in Cassone, 1913
Vegetation, architecture and water were the three elements which Klimt liked to combine in his last landscapes, ultimately an expression of his search for balance and harmony between these different elements. In order to achieve an even closer link, the pictures became almost monochrome, and the structures show the influence of Cubism.

Woman with Hat and Bag, figure repeated to the right, study for *Portrait of Adele Bloch-Bauer II*, 1911

Cubism. There are still no human beings, but there are cypresses – familiar graveyard symbols of death because of their supposed power to hinder the decomposition of the human body.

It is somewhat surprising that he, the colourist, gradually gave up his customary bright colours in his late landscapes of 1915 to 1918 in favour of more sombre monochrome effects. No trace of this muted atmosphere is to be found in his portraits or in his other studio paintings, it is confined to the landscapes, which in all probability are a more faithful reflection of his private life. The sombre atmosphere may well be a reaction to the outbreak of the First World War in the summer of 1914 and to the death of his mother in 1915.

The war marked the end of the great cultural flowering of Vienna, the end of an epoch, a century. What remains of Klimt's contribution to this epoch; what is the significance of his work for posterity? First, that he helped as charismatic leader of the Secession to gain international significance and recognition for Austrian painters. Then, that he established certain constant factors in his own paintings: square format, diagonal composition, asymmetrical construction, geometrical stylisation, setting of the subject in mosaics, backgrounds in gold and silver leaf… and erotic power. Above all, that he was one of the first to succeed in combining figurative with abstract painting, if one regards the wealth of motifs surrounding his figures not merely as decorative, but as an abstract, autonomous irreality which contributes to the distinctive quality of the faces. Finally, that there is a radical departure in his landscapes from the

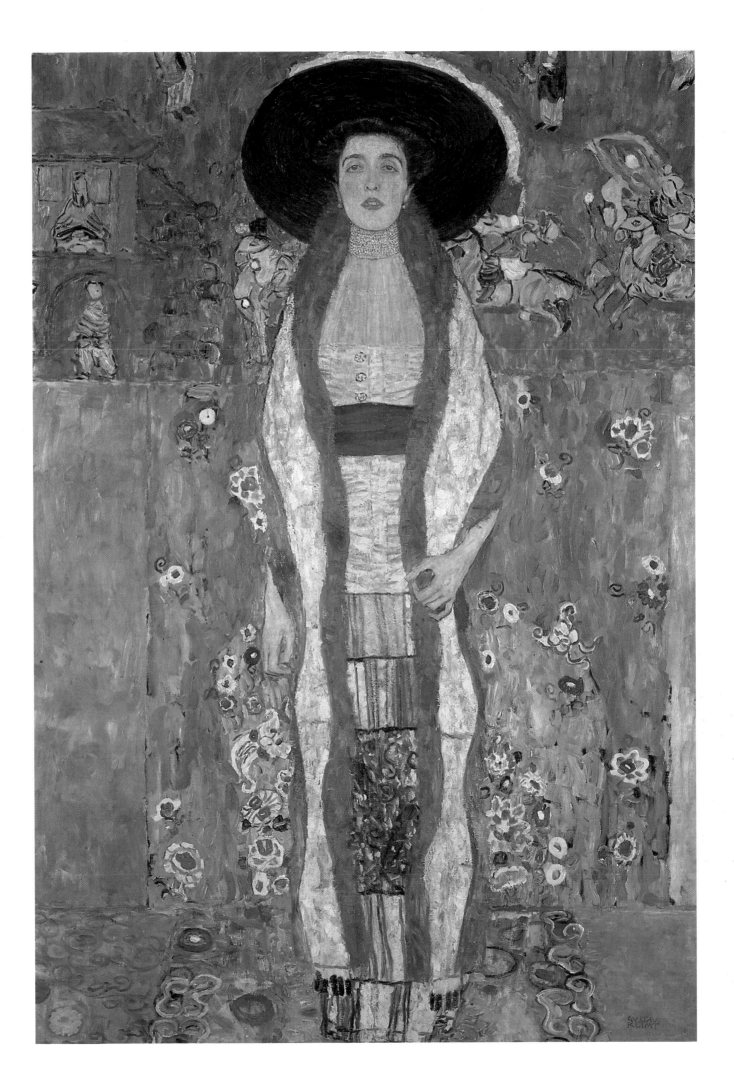

Portrait of Eugenia Primavesi, c. 1913/14
The same borders and facings of flowers adorn the landscape on p. 79 and this portrait; they appeal to the unconscious, creating an immediate effect.

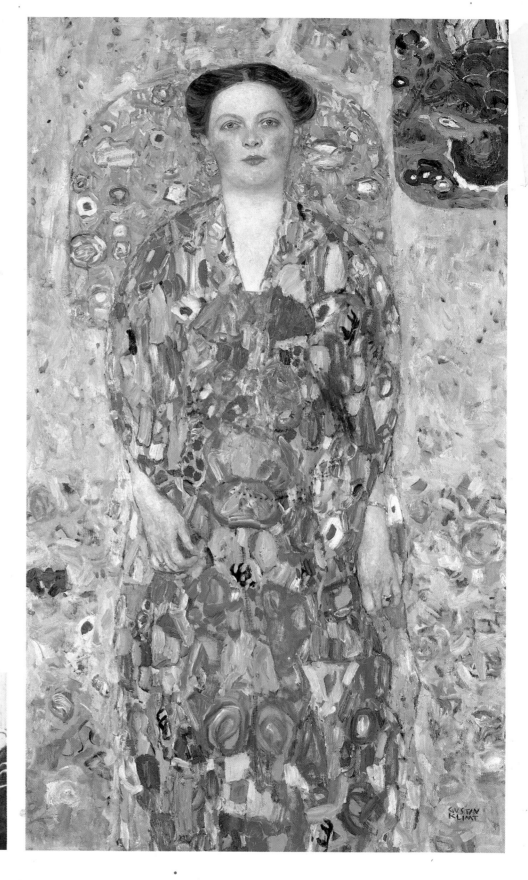

Eugenia Primavesi in Winkelsdorf, undated

Impressionists and also from van Gogh – with whom he has sometimes been compared – in the density and profusion of plants, flowers and trees, in the complete absence of human beings, in the almost complete disappearance of horizon and sky, in the innumerable tiny points without any true resemblance to Pointillism, and in the exceptional richness of colour in his palette…

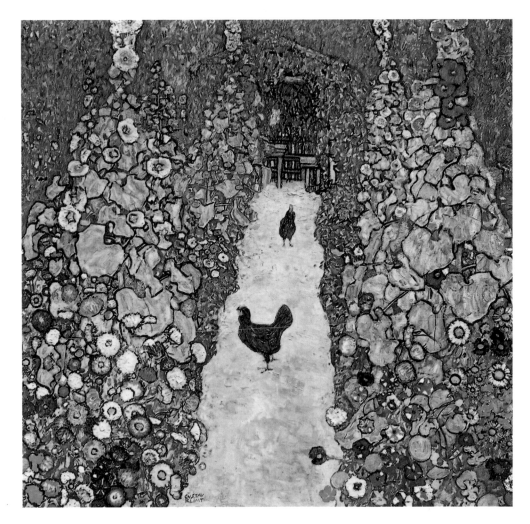

Garden Path with Chickens, 1916
One cannot avoid comparing this landscape painting with the portrait on p. 78, given the strong similarities in structure and technique and in psychological effect.

On all of this, which amounts to a considerable achievement and which would continue to be important to artists and art in a variety of ways, Klimt commented on with modesty: "I can paint and draw. I believe that myself, and some other people say they believe it. But I am not entirely certain that it is true. Two things alone are certain:

1. No self-portrait of me exists. I am not interested in myself as material for a picture, but rather in other people, especially women, and even more in other phenomena. I am convinced that as a person I am not especially interesting. There's nothing remarkable to be seen in me. I am a painter, one who paints every day from morning till evening. Figures, landscapes, occasionally portraits.

2. Words, spoken or written, do not come easily to me, especially when I'm supposed to be saying something about myself or my work. If I have to write a simple letter I get just as scared as if I was going to be sea-sick.

So people will just have to do without an artistic or literary self-portrait – which is just as well. Anyone who wants to find out about me – as an artist, which is all that's of interest – should look attentively at my pictures and try to learn from them what I am and what I want."[17]

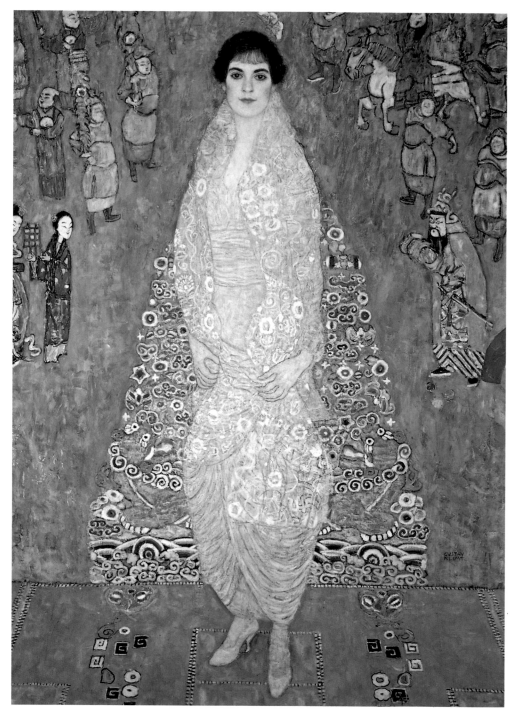

In Low-Cut Evening Dress, study for
Portrait of Baroness Elisabeth Bachofen-Echt, 1916

Imperial gown, yellow silk with embroidery,
K'ang Hsi, 18th century

Portrait of Baroness Elisabeth Bachofen-Echt,
c. 1914
Like Monet and van Gogh, Klimt drew on
Japanese art for an abundance of birds, animals
and oriental figures, found strewn across his canvases.

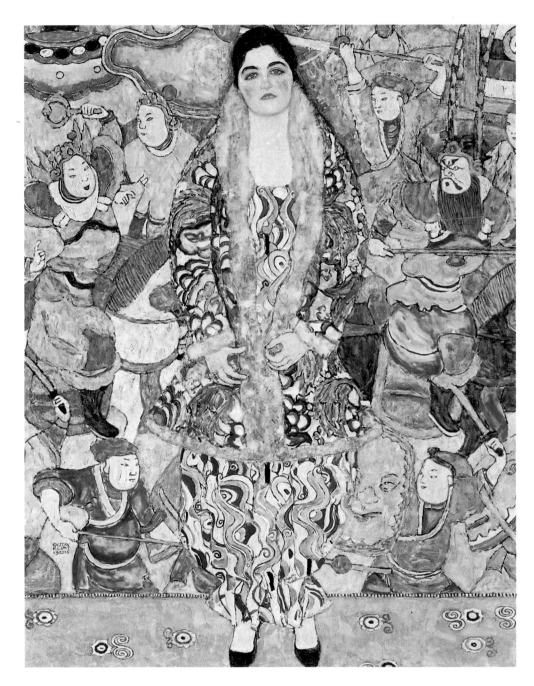

Portrait of Friederike Maria Beer, 1916
It is impossible to overestimate the influence of
Japanese artists on Impressionism and Art Nou-
veau.

Vincent van Gogh: ***Le Père Tanguy***, c. 1887

Claude Monet: ***La Japonaise (Camille Monet in
Japanese costume)***, 1876

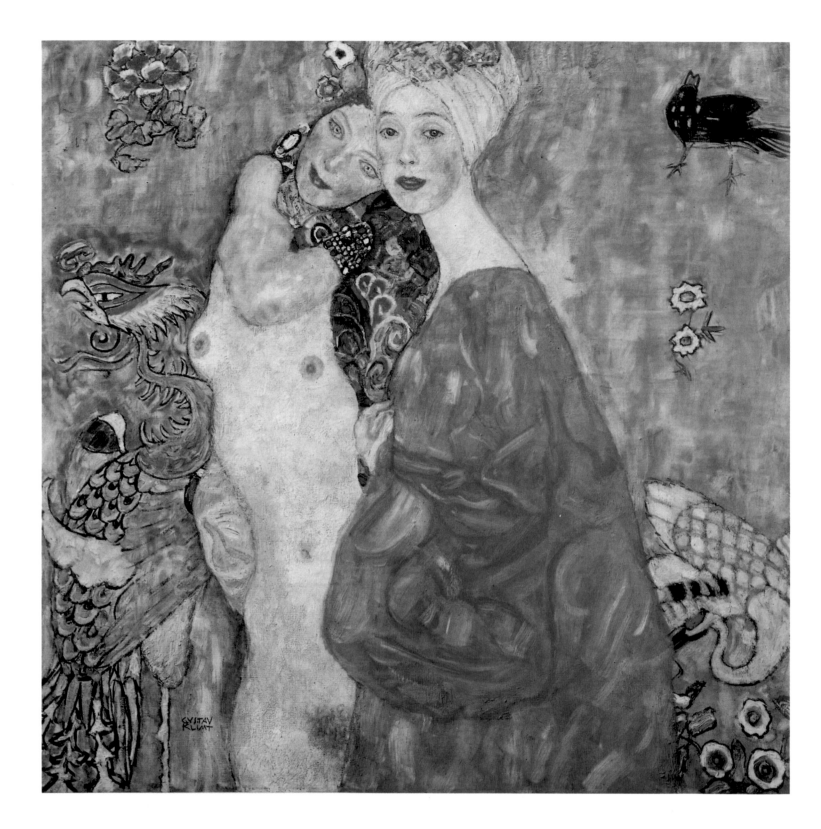

All Art is Erotic

"The first ornament that was ever born, the cross, was erotic in origin. The first work of art, the first artistic deed which the first artist smeared on the wall in order to work off his excess. A horizontal line: recumbent woman. A vertical line: man penetrating her… But man of our time, following an inner compulsion to smear the walls with erotic symbols, is criminal or degenerate… Since ornament is no longer a coherent organic part of our culture, it can no longer be an expression of our culture."

Thus wrote Adolf Loos in his article "Ornament and Crime", which begins with the famous sentence: "All art is erotic". The intention behind the article was to stigmatise the "erotic insalubrity" of Klimt and the other artists of the Wiener Werkstätten. Klimt, laughing at this new Savonarola of art, gave his reply in the form of the *Self-portrait with Genitals,* which is at once a caricature and a confession of faith.

If there is any artist whose "whole art is indeed erotic", then that artist is Gustav Klimt. Woman is his all-absorbing theme: he paints her naked or gloriously adorned, moving, sitting, standing, lying, in all poses, with all gestures, even the most intimate… Ready to kiss and be kissed, in ecstasy, in voluptuous expectation… Like Rodin, with whom he shares this passion to portray woman in all her moods, he always needs two or three naked models in his studio when he is working, even if he does not paint them. An intensive voyeur, a draughtsman not unlike a tabloid journalist, he catches woman in the pose that excites him and moving in a way that stirs his libido. And as we observe the result of his work, the body of a female on a couch with all her natural sensuality and secret activities revealed, we too become voyeurs; he makes us his accomplices.

More than 3000 of Klimt's drawings have survived. For a long time they were neglected, but now they are regarded as an essential supplement to his paintings. The drawings indeed show Klimt's paintings in the making, reflecting his daily striving to grasp reality, the planning of his compositions and their variant forms. As with Japanese art, the erotic tension which grips the viewer arises from the interrelation between that which is revealed and that which is concealed. The close relationship between artist and model is often so apparent that viewing Klimt's drawings seems an indiscretion, an intrusion; one feels oneself becoming a voyeur. But is this not precisely what the rogue intended, he who said of his drawings that they were a homage to "the naïve and lascivious race of the hypersensitive", to which he himself belonged?

Nude Figures, two girls standing, 1916/17

The Girl-Friends, 1916/17
Klimt was so attached to women, and to painting pictures of women, that he did not hesitate to depict women's love; he had already done so in *Water Serpents*. When painting men he seemed to do so reluctantly, and only when the occasion demanded it.

Lovers, drawn from the right, 1914
As in the erotic art of Japan, tension is created by the interplay between what is revealed and what is concealed.

Semi-nude seated, with closed eyes, 1913

Semi-nude lying, ***drawn from the right***, 1914/15
Is it not Klimt's avowed aim to make voyeurs of
us all, wanting us to share his emotions? Does he
not say that his drawings of women are a hom-
age to "the naïve and lascivious race of the
hypersensitive", to which he himself belongs?

Semi-nude seated, reclining, 1913
So close is the intimacy between Klimt and his
models, always at hand, naked, in his studio, that
the viewer almost feels an intruder.

Adam and Eve (unfinished), 1917/18
Not even Klimt can treat the subject of "Adam and Eve" without the presence of the male. Yet he succeeds in making him a kind of decorative accessory. Using a technique observed in ancient vase painting, he paints him darker than the triumphant figure of Eve, the alluring carnal Viennese with her gently rounded flesh, the obvious star of the picture.

Woman seated with thighs apart, drawing, 1916/17
Klimt's drawings give expression to the close contact between his model and himself. Before concealing her in his paintings beneath sparkling ornaments, he likes to capture her most intimate and secret moments.

Woman seated, en face, study for **Portrait of Amalie Zuckerkandl**, 1917/18

Portrait of a Lady, en face, 1917/18
This unfinished portrait from the last year of Klimt's life makes it possible to see something of his working methods. When the outline of the figure is in place, the face is worked on first; then comes the accompanying décor.

Klimt's drawings are the quintessence of voluptuousness. They do not have the aggressiveness and despair of Schiele's drawings, the cynicism of Picasso, the frenzy of Toulouse-Lautrec. He is closer to the refined and elegant eroticism of Ingres or Matisse. His sensuousness attests to his taste for decadent aestheticism, which cannot be taken from him or forbidden, as Loos would have liked. This combination of the erotic and the aesthetic persists even in the depiction of the most daring and provocative poses and in the detailed reproduction of the body's erogenous zones. Although he has been charged with pornography, Klimt is never cruel or vulgar. Klimt the draughtsman always seems to be flirting with his subject. The drawings are those of an observant lover, gently caressing the body he loves so as to arouse it in every pose, and striving to capture a moment of ecstasy, to make of it an atom of eternity. One steps into this world as into a temple, where the pillars are women's thighs through which one passes in order to ascend to heaven.

Klimt, life's great voyeur and seer, lover of woman and servant of Eros, preferred to multiply the bodies of his fleshly creations and portray the love of women, as in *Water Serpents I* and *II* and, shortly before his death, *The Girl-Friends* (see p. 82), rather than admit man to his paintings. When he did admit him, it was as if with pity, as for instance in the unfinished *Adam and Eve* (see p. 86). Even here man is an accessory, and not the chief figure in the picture. The emphasis is on Eve, curvaceous,

Portrait of Johanna Staude (unfinished), 1917/18
To what new development in his work might Klimt have led us? Would he have yielded even more to the influence of Schiele, with an even more savage eroticism? His uncompleted works leave the question unanswered.

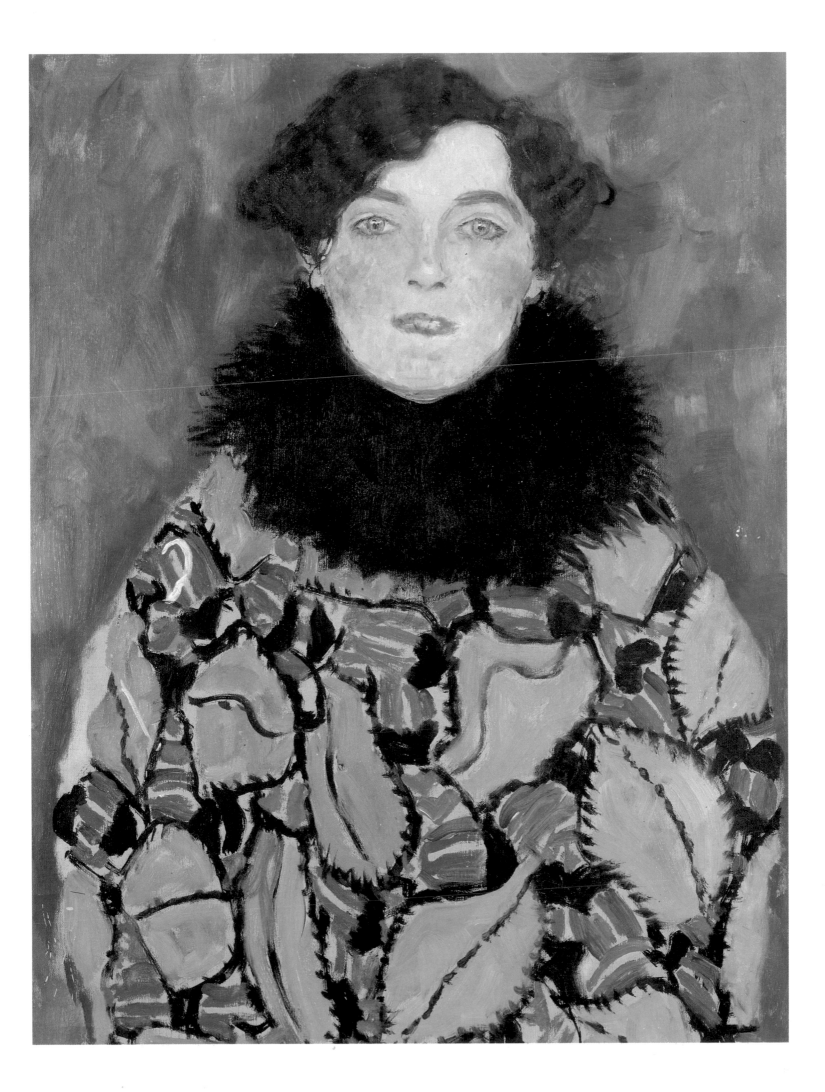

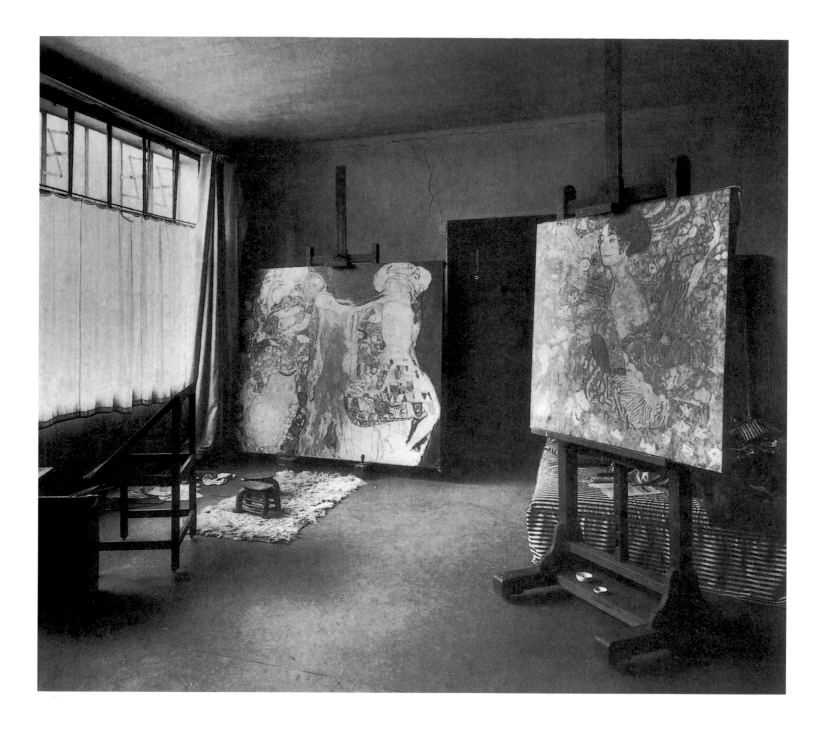

Klimt's studio, with the pictures on which he was working at the end, shows us more about the way in which he worked. He always worked on several canvases at once, covering them gradually with shapes and colours.

like a well-nourished girl from Vienna. Even the flesh tones are different in the male and female figures, following a technique which the artist adopted from antique vase painting. The style is less dense; photographically faithful reproduction has given way to a compromise between planar and spatial representation. The *femme fatale* has become more approachable, she is more biddable, she is waiting...

Klimt's death in February 1918, following a stroke, prevented him from finishing such works as the *Portrait of Johanna Staude* (see p. 89) and the famous *Bride* (see p. 91). Their unfinished state allows us to gain entry to Klimt's world; as he went, he left a door open for us. One sees that the drawing is like a print in the developing tray, before the picture fully emerges. The nude drawing in all its intimacy is gradually bewitched or shamed into colour as it develops.

Klimt's whole work demonstrates the veracity of the first words in Loos's essay – "All art is erotic" – but it entirely disproves the second ob-

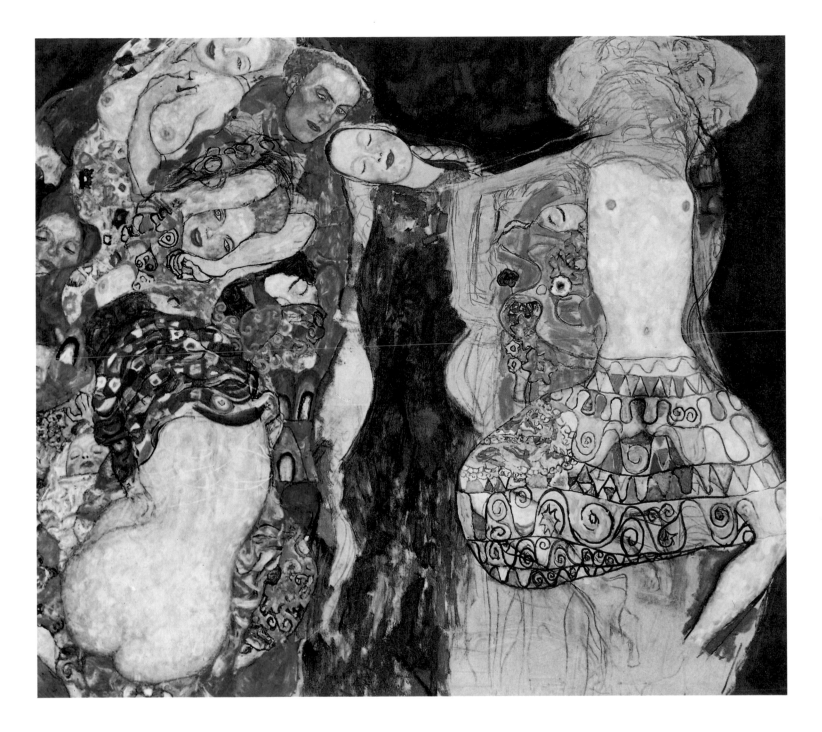

servation, that "ornament has no connection with civilisation". On the contrary: decorative luxuriance signified for Klimt an enrichment of reality, a means of letting the unconscious penetrate conscious life, as with the Freudian dream cherished later by the Surrealists. The beauty of woman, magnified by the golden splendour of aestheticism and its colours, allowed Klimt to recreate the glory of a lost paradise where man, condemned to a transient flowering, can experience moments of supreme bliss before he fades once more in nature's eternal cycle.

The Bride (unfinished), 1917/18
The four pictures put together here are typical of the working method of Klimt in his final period. In all of them, gold has been replaced by colours which rival those of Bonnard or Matisse, artists whom Klimt revered. Seen as it were from above, in pyramid or kaleidoscope form, the compositions are influenced by Japanese art. The themes are still drawn from Eros and from the life cycle, but there is no longer any trace of the unpleasant aspects, or of the dark shades of death.

Gustav Klimt 1862–1918: Life and Work

1862 Gustav Klimt is born in Baumgarten near Vienna on 14th July, second of the seven children of the engraver Ernst Klimt and his wife Anna, née Finster.

1876 Gustav Klimt enters the Kunstgewerbeschule in Vienna, where he studies under Ferdinand Laufberger and Julius Victor Berger until 1883.

1877 His younger brother, Ernst, becomes a fellow student at the Kunstgewerbeschule. They collaborate in drawing portraits from photographs, and sell them at 6 guilders a piece.

1879 With their friend Franz Matsch, Gustav and Ernst Klimt undertake decorative work in the courtyard of the Kunsthistorisches Museum in Vienna.

1880 The three young men receive numerous commissions: four allegories for the ceiling of the Palais Sturany in Vienna; the ceiling of the spa house in Karlsbad, Czechoslovakia.

1885 Interior decoration of the Villa Hermes, a favourite out-of-town residence of the Empress Elisabeth, from plans drawn by Hans Makart.

1886 In the Burgtheater Klimt's style takes a new direction, distinct from that of his two fellow-workers. He moves away from Academicism; each of the three artists works independently.

1888 Klimt receives the Golden Order of Merit from the hand of Emperor Franz Josef for his contribution to art.

1890 Decoration of the staircase in the Kunsthistorisches Museum in Vienna. Klimt receives the Imperial Award (400 guilders) for the work *Auditorium in the Old Burgtheater, Vienna.*

1892 Klimt's father dies of a stroke – as will Klimt himself at a later date. Death of Klimt's brother, Ernst.

1893 The Minister of Culture refuses to confirm Klimt's appointment as Professor at the Academy of Art.

1894 Klimt and Matsch are commissioned to produce paintings for the walls and ceiling of the Great Hall of the University.

1895 Klimt is awarded the Grand Prize of Antwerp, for his decoration of the Esterházy Schlosstheater in Totis, Hungary.

1897 The official revolt: Klimt is a founder member of the Secession, and is elected presi-

Members of the Vienna Secession at the Beethoven Exhibition, 1902.
From left to right: Anton Stark, Gustav Klimt, Kolo Moser (in front of Klimt, with hat), Adolf Böhm, Maximilian Lenz (lying), Ernst Stöhr (with hat), Wilhelm List, Emil Orlik (sitting), Maximilian Kurzweil (with cap), Leopold Stolba, Carl Moll (lying propped on his elbow), Rudolf Bacher

Gustav Klimt
Albertina, Vienna

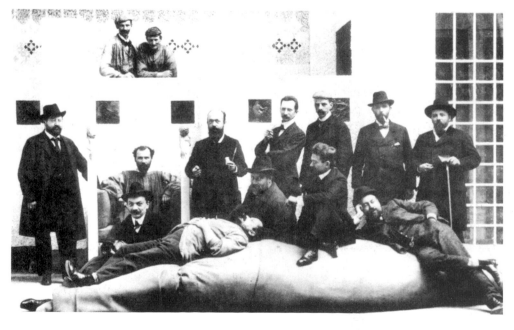

Klimt in the garden of his studio
Albertina, Vienna

In painter's smock, with cat
Bildarchiv der Österreichischen Nationalbibliothek, Vienna

dent. He begins to spend the summer months in the region of Kammer on the Attersee, with his companion Emilie Flöge: first landscape paintings.

1898 Poster for the first Secession Exhibition; the Secession group founds the journal "Ver Sacrum".

1900 The painting *Philosophy*, rejected at the Secession Exhibition by 87 professors, is awarded a gold medal at the World Exhibition in Paris.

1901 Further scandal at the Secession Exhibition: his work *Medicine* is the subject of a parliamentary question to the Minister of Education.

1902 Meeting with Auguste Rodin, who admires the *Beethoven Frieze*.

1903 Visits to Venice, Ravenna and Florence. Beginning of the "golden phase". The paintings for the Great Hall of the University are moved to the Österreichische Galerie, under protest from Klimt. Retrospective of Klimt's work in the Secession House.

1904 Klimt draws the plans for the wall mosaics in the Palais Stoclet, Brussels, to be executed by the Wiener Werkstätten.

1905 Klimt buys back the University paintings from the Ministry. He and his friends leave the Secession.

1907 Klimt gets to know the young Egon Schiele. Picasso paints *Les Demoiselles d'Avignon*.

1908 16 paintings shown at the Kunstschau. The Galleria d'Arte Moderna in Rome buys *The Three Ages of Woman*, the Österreichische Staatsgalerie *The Kiss*.

1909 Beginning of work on the Stoclet Frieze. Visit to Paris, where Klimt discovers with great interest the work of Toulouse-

On the Attersee, 1909
Bildarchiv der Österreichischen Nationalbibliothek, Vienna

Lautrec and Fauvism: van Gogh, Munch, Toorop, Gauguin, Bonnard and Matisse are represented in the Kunstschau.

1910 Success at the 9th Venice Biennale.

1911 *Death and Life* receives first prize at the World Exhibition in Rome. Klimt travels to Rome, Florence, Brussels, London and Madrid.

1912 Klimt replaces the background of *Death and Life* with blue (in the manner of Matisse).

1914 Expressionist criticism of Klimt's work.

1915 Death of Klimt's mother. His palette becomes darker, his landscape paintings more monochromatic.

1916 Klimt takes part in the Exhibition of the Bund Österreichischer Künstler put on by the Berlin Secession, with Egon Schiele, Kokoschka and Faistauer. Death of Emperor Franz Josef, two years before the dissolution of the Empire and Klimt's own death.

1917 Beginning of work on *The Bride* and *Adam and Eve*. Klimt is elected honorary member of the Academies of Art in Vienna and Munich.

1918 Following a stroke, Klimt dies on 6th February, with numerous paintings unfinished. End of the Empire; foundation of the Republic of Austria and six further republics from the territories of the former Empire. Death of Egon Schiele, Otto Wagner, Ferdinand Hodler, Koloman Moser…

List of Plates

46 right
Water Serpents I (Girl-Friends) *(Wasserschlangen I (Freundinnen))*, 1904–07
Gold and watercolours on parchment, 50 x 20 cm
Österreichische Galerie, Vienna

47
Water Serpents II (Girl-Friends) *(Wasserschlangen II (Freundinnen))*, 1904–07
Oil on canvas, 80 x 145 cm
Private collection

48 left
The Three Ages of Woman *(Die drei Lebensalter)*, 1905
Oil on canvas, 180 x 180 cm
Galleria Nazionale d'Arte Moderna, Rome

48 right
Auguste Rodin:
Celle qui fut la belle Heaulmière, 1885
Bronze
Musée Rodin, Paris

49
Portrait of Margaret Stonborough-Wittgenstein *(Bildnis Margaret Stonborough-Wittgenstein)*, 1905
Oil on canvas, 180 x 90.5 cm
Bayerische Staatsgemäldesammlungen, Munich

50
Farm Garden (Flower Garden) *(Bauerngarten (Blumengarten))*, 1905/06
Oil on canvas, 110 x 110 cm
Národní Galerie, Prague

52
Pear Tree *(Birnbaum)*, 1903
Oil and casein on canvas, 101 x 101 cm
The Busch-Reisinger Museum, Harvard University, Gift of Otto Kallir, Cambridge (MA)

53
Farm Garden with Sunflowers *(Bauerngarten mit Sonnenblumen)*, 1905/06
Oil on canvas, 110 x 110 cm
Österreichische Galerie, Vienna

54
Working study for Stoclet Frieze, composition for narrow wall, 1905–09
Tempera, watercolour, gold paint, silver-bronze, crayon, pencil, opaque white, gold leaf and silver leaf on paper, 197 x 91 cm
Österreichisches Museum für Angewandte Kunst, Vienna

56 left
Expectation *(Die Erwartung)*, working design for Stoclet Frieze, c. 1905–09
Tempera, watercolour, gold paint, silver-bronze, crayon, pencil, opaque white, gold leaf and silver leaf on paper, 193 x 115 cm
Österreichisches Museum für Angewandte Kunst, Vienna

56 right
Fulfilment *(Die Erfüllung)*, working design for Stoclet Frieze, c. 1905–09
Tempera, watercolour, gold paint, silver-bronze, crayon, pencil, opaque white, gold leaf and silver leaf on paper, 194 x 121 cm
Österreichisches Museum für Angewandte Kunst, Vienna

57
The Royal Scribe Ptahmose, 19th Dynasty
Museum Leyden, Leyden

58
Tree of Life *(Lebensbaum)*, centre, working design for Stoclet Frieze, c. 1905–09
Tempera, watercolour, gold paint, silver-bronze, crayon, pencil, opaque white, gold leaf and silver leaf on paper, 195 x 102 cm
Österreichisches Museum für Angewandte Kunst, Vienna

59
Klimt in painter's smock and Emilie Flöge in a dress
Bildarchiv der Österreichischen Nationalgalerie, Vienna

60
Diego Velasquez:
The Infanta Maria Teresa, c. 1652
Oil on canvas, dimensions unknown
Kunsthistorisches Museum, Vienna

61
Portrait of Fritza Riedler *(Bildnis Fritza Riedler)*, 1906
Oil on canvas, 153 x 133 cm
Österreichische Galerie, Vienna

62
Portrait of Adele Bloch-Bauer I *(Bildnis Adele Bloch-Bauer I)*, 1907
Oil, gold on canvas, 138 x 138 cm
Österreichische Galerie, Vienna

63
The Kiss *(Der Kuß)*, 1907/08
Oil on canvas, 180 x 180 cm
Österreichische Galerie, Vienna

64
Danae *(Danae)*, c. 1907/08
Oil on canvas, 77 x 83 cm
Private collection

65 above
Egon Schiele:
Study for "Danae", 1909
Crayon and pencil, 30.6 x 44.3 cm
Graphische Sammlung Albertina, Vienna

65 centre
Crouching semi-nude, viewed from the right *(Kauernder Halbakt nach rechts)*, study for "Leda", 1913/14
Pencil, 36.8 x 56 cm
Dr Rudolf Leopold Collection, Vienna

65 below
Leda *(Leda)*, 1917
Oil on canvas, 99 x 99 cm
Destroyed by fire in Schloss Immendorf in 1945

66
Portrait of Mäda Primavesi *(Bildnis Mäda Primavesi)*, c. 1912
Oil on canvas, 150 x 110.5 cm
The Metropolitan Museum of Art, gift of Andre and Clara Mertens, in memory of her mother, Jenny Pulitzer Steiner, 1964 (64.148), New York

67
Composition sketch depicting Mäda Primavesi, formerly in the possession of Emilie Flöge, 1913
Materials, dimensions and location unknown

68
Lady with Hat and Feather Boa *(Dame mit Hut und Federboa)*, 1909
Oil on canvas, 69 x 55 cm
Österreichische Galerie, Vienna

69
Black Feather Hat (Lady with Feather Hat) *(Der schwarze Federhut (Dame mit Federhut))*, 1910
Oil on canvas, 79 x 63 cm
Private collection

70
Death and Life *(Tod und Leben)*, 1916
Oil on canvas, 178 x 198 cm
Dr Rudolf Leopold Collection, Vienna

71
The Virgin *(Die Jungfrau)*, 1913
Oil on canvas, 190 x 200 cm
Národní Galerie, Prague

72
The Dancer *(Die Tänzerin)*, c. 1916–18
Oil on canvas, 180 x 90 cm
Private collection

73 above left
Sunflower *(Die Sonnenblume)*, 1906/07
Oil on canvas, 110 x 110 cm
Private collection

73 above right
Apple Tree I *(Apfelbaum I)*, c. 1912
Oil on canvas, 110 x 110 cm
Österreichische Galerie, Vienna

73 below left
Farm Garden with Crucifix *(Bauerngarten mit Kruzifix)*, 1911/12
Oil on canvas, 110 x 110 cm
Destroyed by fire in Schloss Immendorf in 1945

73 below right
Poppy Field *(Mohnwiese)*, 1907
Oil on canvas, 110 x 110 cm
Österreichische Galerie, Vienna

74 left
Forester's House, Weissenbach on Lake Attersee *(Forsthaus in Weißenbach am Attersee)*, 1912
Oil on canvas, 110 x 110 cm
Private collection

74 right
Schloss Kammer on the Attersee III, 1910
Oil on canvas, 110 x 110 cm
Österreichische Galerie, Vienna

75
Schloss Kammer on the Attersee I, c. 1908
Oil on canvas, 110 x 110 cm
Národní Galerie, Prague

76 left
The Church in Cassone (Landscape with Cypresses) *(Kirche in Cassone (Landschaft mit Zypressen))*, 1913
Oil on canvas, 110 x 110 cm
Private collection, Graz

76 right
Woman with Hat and Bag, figure repeated to the right, study for "Portrait of Adele Bloch-Bauer II", 1911
Pencil, 56.7 x 37.2 cm
Graphische Sammlung Albertina, Vienna

77
Portrait of Adele Bloch-Bauer II *(Bildnis Adele Bloch-Bauer II)*, 1912
Oil on canvas, 190 x 120 cm
Österreichische Galerie, Vienna

78 right
Portrait of Eugenia Primavesi *(Bildnis Eugenia Primavesi)*, c. 1913/14
Oil on canvas, 140 x 84 cm
Private collection, U.S.A.

79
Garden Path with Chickens *(Gartenweg mit Hühnern)*, 1916
Oil on canvas, 110 x 110 cm
Destroyed by fire in Schloss Immendorf in 1945

80 above left
In Low-Cut Evening Dress
Study for "Portrait of Baroness Bachofen-Echt", 1916
Pencil, 48.5 x 27.5 cm
Neue Galerie der Stadt Linz, Linz

80 right
Portrait of Baroness Elisabeth Bachofen-Echt *(Bildnis Baronin Elisabeth Bachofen-Echt)*, c. 1914
Oil on canvas, 180 x 128 cm
Private collection

81 left
Portrait of Friederike Maria Beer *(Bildnis Friederike Maria Beer)*, 1916
Oil on canvas, 168 x 130 cm
Private collection

81 above right
Vincent van Gogh:
Le Père Tanguy, c. 1887
Oil on canvas, 92 x 73 cm
Musée Rodin, Paris

81 below right
Claude Monet:
La Japonaise (Camille Monet in Japanese costume), 1876
Oil on canvas, 231 x 142 cm
Courtesy Museum of Fine Arts, 1951 Purchase Fund, Boston (MA)

82
The Girl-Friends *(Die Freundinnen)*, 1916/17
Oil on canvas, 99 x 99 cm
Destroyed by fire in Schloss Immendorf in 1945

83
Nude Figures, two girls standing, 1916/17
Materials, dimensions and owner unknown

84 above
Lovers, drawn from the right *(Liebespaar nach rechts)*,
1914
Pencil, 37.3 x 55.9 cm
Whereabouts unknown

84 below
Semi-nude seated, with closed eyes *(Sitzender Halbakt
mit geschlossenen Augen)*, 1913
Pencil, 56.6 x 37.1 cm
Historisches Museum der Stadt Wien, Vienna

85 above
Semi-nude lying, drawn from the right *(Liegender
Halbakt nach rechts)*, 1914/15
Blue coloured pencil, 37.1 x 55.8 cm
Historisches Museum der Stadt Wien, Vienna

85 below
Semi-nude seated, reclining *(Zurückgelehnt sitzender
Halbakt)*, 1913
Pencil, 55.9 x 37.3 cm
Historisches Museum der Stadt Wien, Vienna

86
Adam and Eve (unfinished) *(Adam und Eva)*, 1917/18
Oil on canvas, 173 x 60 cm
Österreichische Galerie, Vienna

87
Woman seated with thighs apart *(Sitzende Frau mit
gespreizten Schenkeln)*, 1916/17
Pencil, red coloured pencil, white highlights,
57 x 37.5 cm
Private collection

88 left
Portrait of a Lady, en face *(Damenbildnis en face)*,
1917/18
Oil on canvas, 67 x 56 cm
Neue Galerie der Stadt Linz, Wolfgang-Gurlitt-
Museum, Linz

88 right
Woman seated, en face, study for "Portrait of Amalie
Zuckerkandl", 1917/18
Pencil, 57 x 38 cm
Graphische Sammlung Albertina, Vienna

89
Portrait of Johanna Staude (unfinished) *(Bildnis
Johanna Staude)*, 1917/18
Oil on canvas, 70 x 50 cm
Österreichische Galerie, Vienna

91
The Bride (unfinished) *(Die Braut)*, 1917/18
Oil on canvas, 166 x 190 cm
Private collection

92 below right
Photograph: anonymous
Graphische Sammlung Albertina, Vienna

Notes

1 Bertha Zuckerkandl-Szeps, Eine reinliche Schei-
 dung soll es sein, in: Neues Wiener Journal of 2
 May 1931
2 Catalogue of the first Secession in Vienna, Vienna
 1898
3 Catalogue of the 9th Exhibition of the Vienna
 Secession, Vienna 1900
4 Carl E. Schorske, Wien – Geist und Gesellschaft im
 Fin de siècle, Frankfurt am Main 1982
5 Bertha Zuckerkandl-Szeps, Einiges über Klimt, in:
 Volkszeitung, 6 February 1936. See also: Christian
 M. Nebehay, Gustav Klimt – Sein Leben nach zeit-
 genössischen Berichten und Quellen, Munich 1979,
 p. 174
6 Ludwig Hevesi, Christian M. Nebehay, loc. cit.,
 pp. 170 f.
7 Carl E. Schorske, loc. cit., pp. 208 ff.
8 Catalogue of the 14th Exhibition of the Vienna Se-
 cession, 1902
9 Ludwig Hevesi, Weiteres über Klimt (12 August
 1908), in: Altkunst – Neukunst, Wien 1894–1908,
 Vienna 1909
10 Josef Hoffmann, Kultur und Architektur, 1930
11 ibid.
12 Catalogue of the Kunstschau 1908, Vienna
 1908. See also: Christian M. Nebehay, loc. cit.,
 p. 244
13 Ludwig Hevesi, Acht Jahre Secession, Kritik –
 Polemik – Chronik, Vienna 1906, reprint 1985
14 Bertha Zuckerkandl-Szeps, Einiges über Klimt, in:
 Volkszeitung, 2 June 1936. See also: Christian M.
 Nebehay, loc. cit., p. 254
15 Alessandra Comini, Gustav Klimt, Thames & Hud-
 son, London 1975
16 Joseph Roth, Die Kapuzinergruft, Cologne 1987,
 p. 15
17 Christian M. Nebehay (ed.), Gustav Klimt, Do-
 kumente, Vienna 1969

The publishers gratefully acknowledge the contribution
to the production of this book made by museums, gal-
leries, collectors and photographers. In addition to
those named in the captions, the support of the follow-
ing individuals and institutions is acknowledged: Ar-
tothek, Peissenberg (15 left, 48 left, 49); Archiv für
Kunst und Geschichte, Berlin (29, 82); L. Bezzola, Bät-
terkinden (34); Bruno Jarret/ADAGP, Paris (81 above
right); Jürgen Karpinski, Dresden (35); Erich Lessing,
Archiv für Kunst und Geschichte, Berlin (21); Rein-
hard Öhner, Vienna (6); Fotostudio Otto, Vienna (28
right, 36, 38, 39, 40 above, 41, 42, 43, 46 right, 53, 61,
62, 63, 73 above right, 73 below right, 74 right);
Jochen Remmer, Artothek, Peissenberg (75); Hans
Riha, Vienna (37); Galerie Welz, Salzburg (18, 20 left,
25, 47, 73 above left, 73 below left, 78 right, 79, 80
right, 81 left, 82, 91).

In this series: